AM I THeRe YET?

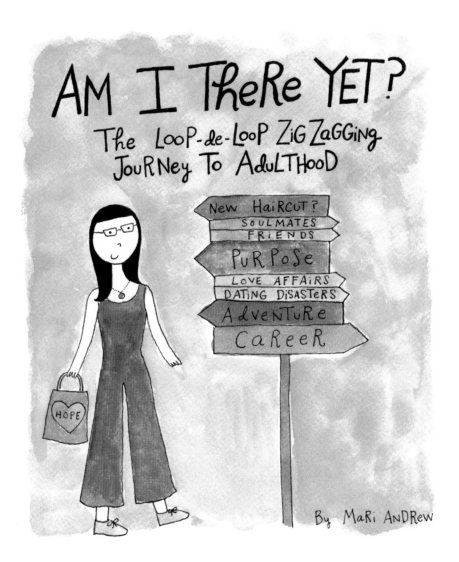

AM I THERE YET?
The Loop-de-Loop Zig Zagging Journey To Adulthood

New Haircut?
Soulmates
Friends
Purpose
Love Affairs
Dating Disasters
Adventure
Career

HOPE

By Mari Andrew

CLARKSON POTTER/PUBLISHERS

NEW YORK

crownpublishing.com
clarksonpotter.com

CLARKSON POTTER is a trademark and POTTER with colophon is a registered
trademark of Penguin Random House LLC.

Library of Congress Cataloging-in-Publication Data
Names: Andrew, Mari, author, artist.
Title: Am I there yet? : the loop-de-loop, zigzagging journey to adulthood /
 Mari Andrew.
Description: First edition. | New York : Clarkson Potter, 2018.
Identifiers: LCCN 2017034814| ISBN 9781524761431 (hardback) | ISBN
 9781524761448 (ebook)
Subjects: LCSH: Andrew, Mari—Caricatures and cartoons. | Coming of
 age—United States—Caricatures and cartoons. | Authors—United
 States—Biography—Caricatures and cartoons. | Illustrators—United
 States—Biography—Caricatures and cartoons. | BISAC: COMICS & GRAPHIC
 NOVELS / Contemporary Women. | SELF-HELP / Personal Growth / Self-Esteem.
Classification: LCC NC1429.A6325 A2 2018 | DDC 741.6092—dc23 LC record available
at https://lccn.loc.gov/2017034814

ISBN 978-1-5247-6143-1
Ebook ISBN 978-1-5247-6144-8

Printed in China

Book and jacket design by Danielle Deschenes

10 9 8 7 6 5 4 3 2 1

First Edition

FOR My MOM

I'M SORRy iTS NOT a GRANDCHILd

CONTENTS

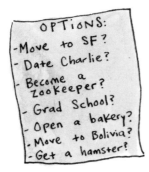

INTRoDUCTiON

In the journey to adulthood, you can use an old guidebook that belonged to your parents, hitting up the same monuments they did when they took the trip. It's probably the only map you have lying around, and it seemed to get them there, even though their lives aren't necessarily what you'd create for yourself. Their worn-out map probably points to a specific route, to achievements by certain ages, to designated stops along the way. This map shows a paved road, the safe way.

But what if nobody gave you a map? Or what if the typical route doesn't do it for you? You might choose something else: to make your own way. Your road might be one that cuts through off-limits industrial areas, shakes up residential neighborhoods, basks in peaceful parks, and ascends treacherous mountains. The road might feel crooked and long while you're on it—perhaps you even create detours for yourself that prolong the journey, putting you far behind your friends. *Am I doing this right?*, you might ask, while everybody else is drinking

everyone_else: Loving life!
#Blessed

cocktails while they watch the sunset. It's interesting (or at least that's how your parents might describe it), but there are a lot of scary and unphotogenic parts, too.

On my way to adulthood, I have made many loops, zigzags, stops, and detours—my map resembles a tangled string. I often wondered if it was leading me deep into a dark forest that would permanently take me off the right path—or worse, leading me nowhere at all.

Looking back, it's clear that the loops, zigzags, stops, and detours didn't take me off course; they pushed me forward. The twisted road began to smooth out when I became an illustrator at age twenty-eight. Doodling on notebook mar-

gins and playing around with lettering had always made me happy, but in my late twenties, I got serious about happiness. I was grieving the death of my father and the end of a serious relationship at the same time. I realized it was up to *me* to put more joy into my life, which started with my daily routine. So I put happiness on my calendar: I'd draw one illustration every day for a year. I bought some cheap supplies, started a new Instagram account to keep myself accountable, and began posting drawings that revealed what I was going through: online dating, new jobs, heartbreak, observations about dining with my girlfriends. After a few months of spending my evenings processing what had happened that day with a pen and watercolor paints, a lot of strangers started seeing my daily illustrations. They'd even call my drawings "relatable," which made me realize that we're all a lot less alone than we think we are.

Suddenly, my bumpy road toward adulthood turned into a sensical map. It began in Chicago, where I went to college and experienced the angst of trying to identify my perfect career track. In my mid-twenties I moved to Washington, D.C., where I found a job I liked, at least, and much more than that through a series of romantic wrong turns and dead ends caused by grief and disappointment. Over the years, I have taken myself on adventures around the world, to Berlin, Lisbon, Rio de Janiero, and then Granada, picking up lessons that continued to push me in surprising directions. I drew all these lessons, confusions, and adventures, and found a whole tribe of people from all over the world who were on similarly squiggly paths.

The essays in this book are notes from the scenic route to adulthood that give some background to the illustrations inspired by love, friendship, home, career, heartbreak, and self-discovery. They won't take you directly from Point A to Point B, but rather hop around my own personal map to share with you what I've learned from these different areas of growing up.

This is not a handy guidebook that will tell you how to find your dream job or how to neatly fold a fitted sheet (the latter is impossible). But it's a scrapbook of my own journey—so far—to adulthood that I hope will bring you comfort if you, too, are on a less-than-direct journey through life. As I made my way through my twenties, other people's tales were guiding lights for me. Every feeling I ever had of "me too" lit up the mysterious path before me, making it not so scary. I wrote this book in the hope that a "me too" feeling might light up your own trail.

CHAPTER 1
OVERCOMING UNCERTAINTY

What iT LookS LiKe Now

What iT WiLL Look LiKe iN HindSiGHT

WORRIES OF YOUR 20s

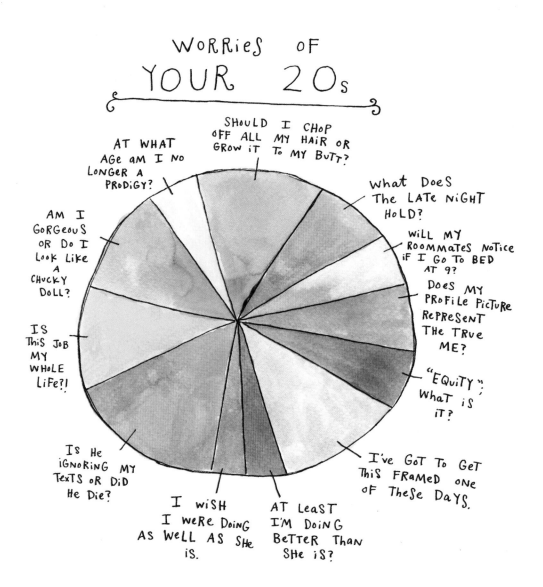

AT WHAT AGE aM I No LONGER A PRODIGY?

SHOULD I CHOP OFF ALL MY HAIR OR GROW iT To MY BuTT?

What DoeS The LATe NiGHT HoLD?

AM I GoRGeouS OR Do I Look Like A CHuCKY DoLL?

WiLL MY RooMMaTeS NoTice iF I Go To BED AT 9?

DoeS MY PRoFiLe PicTuRe RePReSeNT The TRue ME?

IS ThiS JoB MY WHoLE LiFe?!

"EQuiTY", WhaT iS iT?

Is He iGNoRiNG MY TexTS oR DiD He Die?

I've GoT To GeT ThiS FRaMeD oNe oF TheSe DaYS.

I wiSH I weRe DoiNG AS WeLL AS SHe iS.

AT LeasT I'M DoiNG BeTTeR ThaN SHe iS?

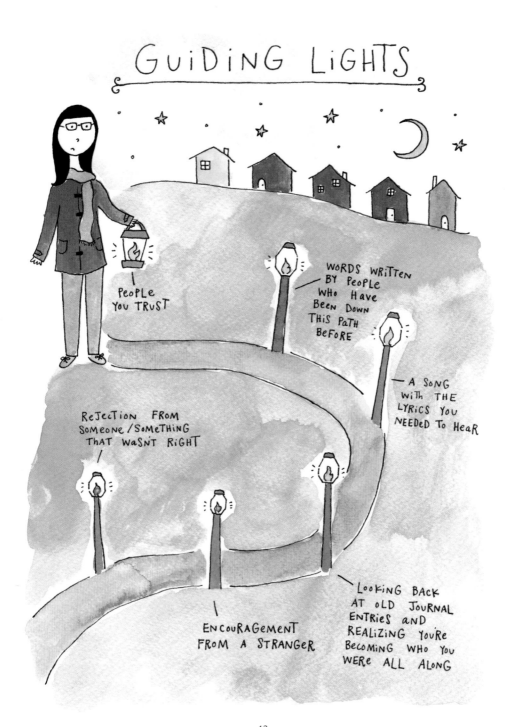

GUIDING LIGHTS

PEOPLE
YOU TRUST

WORDS WRITTEN
BY PEOPLE
WHO HAVE
BEEN DOWN
THIS PATH
BEFORE

A SONG
WITH THE
LYRICS YOU
NEEDED TO HEAR

REJECTION FROM
SOMEONE/SOMETHING
THAT WASN'T RIGHT

ENCOURAGEMENT
FROM A STRANGER

LOOKING BACK
AT OLD JOURNAL
ENTRIES AND
REALIZING YOU'RE
BECOMING WHO YOU
WERE ALL ALONG

SEASONS

When I was twenty-four, I was working at an oppressive law firm in Chicago. I had many jobs around that city in my early twenties, but this one in all its seriousness seemed more finite. After I had worked there only a few weeks, the days felt meaningless and unending—like I had signed my life away to this job. My friend told me with compassion and exasperation, "This isn't your whole life. This is a season in your life. In a couple of years, we'll say 'Remember that weird time you worked at a law firm?'"

She was right. It was a season. A brief, informative season that ended up having much more significance than I could have predicted, but I always forget to add it to my résumé.

It didn't feel like a season at the time; it felt like the rest of my life. That's how most seasons feel while you're living them, and then your surroundings transform just as you're getting settled in. The winter-to-spring shift is slow but dramatic, bringing with it a change of heart and wardrobe. The fall-to-winter transition is quick, taking place the very minute Santa Claus comes floating by

BUD DOESNT KNOW THE QUIET POWER HE POSSESSES

LEAF FEELS HiMSELF GROWiNG, DOESN'T KNOW HE HAS THE RAiN TO THANK

LEAF REACHES FULL POTENTiAL iN SUMMER, DOESN'T KNOW SUNSHiNE iSN'T ALWAYS A GiVEN

LEAF THiNKS HE JUST GOT a BEAUTiFUL NEW CLOAK, DOESN'T KNOW iTS HiS BURiAL GARMENT

at the Macy's Thanksgiving Day Parade. The end of summer is slower. This time of year is precious to everyone. It belongs to the soft cotton part of your heart that never ages past ten years old. You can smell it—fresh pencil shavings and cinnamon.

Fall is a grieving period. It's beautiful and magical and has its own dress code, but it's a season all about loss. Even if you're not sad to see summer go, fall is still heartbreaking, especially when rain sings through empty branches and leaves litter the ground like dusty garnets, waiting to be stuffed in black trash bags.

When I entered my twenties, an older friend told me it was my time to explore. I had ten whole years just to grow and experiment and push my limits. "If you stumble," she said, "that's a great sign. It means you found your edge. You tried something that didn't work, and now you know."

This insight has guided me. I've tried jobs I didn't think I'd be any good at and ended up learning gobs about my interests and abilities. I've dated people I didn't think would be good for me and they're still some of my best friends. I've moved to cities I didn't think fit my personality and, for the first time in my life, found what feels like home in Washington, D.C.

All too often, I was anxious to feel more settled, to have it figured out, to stop learning lessons and just reap the benefits of lessons learned. The most helpful way to get over this anxiety was to think about my life as a collection of seasons, rather than as individual steps. It's tempting at this age to carry around a mental checklist of Things an Adult Should Have and a monthly report card with markings for each Life Category.

There were so many times I felt like I was sitting around waiting. So many times I was meandering around with a heavy heart, mourning the loss of a happier season without any idea what would come

next, and when. I can see now that those were the seasons of loss—my own personal autumns—and they were some of the most important. That's what my law firm job was: an autumn.

Life has seasons that mimic the earth's seasons: times of abundance, times of cultivation. Fall is a season of loss, but it shows you up front what you're losing. That's what makes it so sweet in its melancholy. You can watch summer slip away as a new world takes over. You're a frontline witness to the ultimate triumph of winter, conquering warmth degree by degree, until one evening at five P.M., the night swallows up the afternoon in a sudden coup.

Seasons of loss, like the colder seasons, are the hardest ones to endure, even if you logically understand they won't last forever. I once heard an interview with an artist whose father died at the height of his creative success. He was really close with his dad, and spent the next few years in a tense combination of obligatory gratitude and overwhelming sadness.

When asked to describe loss, this guy said that it was like having the casino cashier gone. He compared everything that happened to him—any happiness, any difficulty, any mundanity—to a poker chip, saying his father would validate those experiences like a cashier, making them worth something. His father turned every one of the man's moments into something meaningful just by listening to his stories.

After his father died, the man said he was sitting among piles and piles of worthless poker chips. He was dwelling in loss, running his fingers through it. He was a witness to his own grief. It's really hard to sit with loss; I'm doing it now. My dad died in 2015.

But it takes so much discipline to resist numbing oneself and skipping quickly to the next season. It's even hard to watch someone else sit in it; hearing someone say "I'm hurting" calls for immediate action. It's a lot easier to tell someone, "Things will get better," "Look on the bright side," or "Everything happens for a reason!," rather than "I can't imagine what you're going through—I'm so sorry."

Just like seasons of the year, seasons of life don't have a finish line. Wearing a sundress in the middle of winter isn't going to make it go by any faster. Pretending the cold doesn't exist isn't nearly as effective as making the most of the silence a snowfall brings. Even the most die-hard winter-haters can probably find some beauty in a cold morning with hot coffee, and can appreciate that the inevitable return of summer makes those chilly mornings seem all the more cozy.

Now in September, I dwell in both "actual fall" and "life fall" seasons of loss. I'm trying to learn from the calendar to make sense of life. It's not easy. It's also not my whole life; it's a season. And there is a ton of beauty in it.

SEARCHING FOR YOURSELF VS. CREATING YOURSELF

 EXPERIMENTING WITH a HAIRCUT

 MAKING YOUR HAIRCUT THE BEST iT CAN BE

 FIGURING THESE OUT

 EXPLORING PLACES TO LIVE

 MAKING A PLACE YOUR HOME

 TRYING ON TRENDS

 WEARING WHAT MAKES YOU FEEL POWERFUL / BOUNCY / FUN / CUTE / ELEGANT / HOWEVER YOU WANT TO FEEL

 POSSIBLE CAREERS:
- AMBASSADOR
- MAP MAKER
- EX PAT
- POET
- FOOD BLOGGER
- JOURNALIST
- GOWN DESIGNER

TAKING NOTE OF PASSIONS and ABILITIES

 DIVING IN AND DOING YOUR BEST

JOBS IN YOUR 20s

BARISTA

COWORKER: GUY WITH NOSE RING AND BLEACHED HAIR WHO INSISTS ON THE LOUDEST VOLUME

POWER ACCESSORY: FLORAL APRON

SKILL GAINED: PREDICTING CUSTOMERS' ORDERS BASED ON THEIR OUTFITS

BARTENDER

COWORKER: "I'M A BEER SNOB"

POWER ACCESSORY: SENSIBLE SHOES

SKILL GAINED: BALANCE

ENGLISH TEACHER ABROAD

Hi
Hiya
Howdy
Hey Girl
Sup

COWORKER: EARNEST IDEALIST WHO DEMANDS TO PRACTICE NEW LANGUAGE EVEN IN PRIVATE

POWER ACCESSORY: SCARF FROM LOCAL BOUTIQUE, WORN IN HAIR

SKILL GAINED: COHERENCY WHILE HUNGOVER

RETAIL FOR COMMISSION

COWORKER: COMPETITIVE PROFESSIONAL SALESPERSON WHO HAS BEEN AT THIS FOR 20 YEARS

POWER ACCESSORY: NAMETAG THAT SAYS "HAPPY TO HELP"

SKILL GAINED: SMILING THROUGH PAIN

ENTRY-LEVEL ADMINISTRATIVE PERSON

COWORKER: 24-YEAR-OLD GOING ON 45

POWER ACCESSORY: RELATIVELY FLATTERING PENCIL SKIRT

SKILL GAINED: CLOSING INTERNET BROWSER AS BOSS WALKS BY

FIRST JOB IN DREAM INDUSTRY

COWORKER: SOMEONE WHO IS BETTER AT IT

POWER ACCESSORY: PIECE OF JEWELRY TO CELEBRATE GETTING THIS JOB

SKILL GAINED: PERSISTENCE

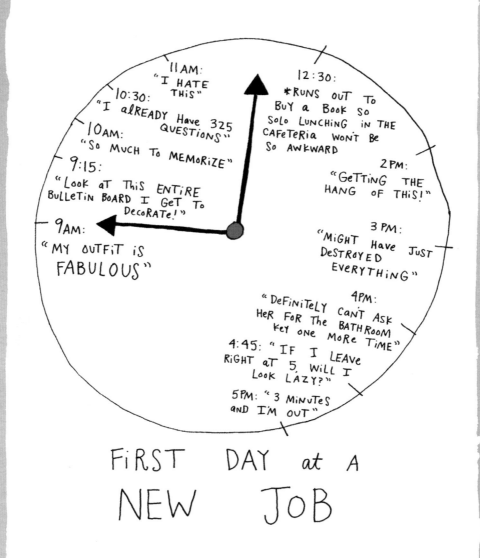

FIRST DAY at A
NEW JOB

OPTIONS

One summer I went to San Francisco to visit a love interest. I left behind Washington, D.C.'s, summer heat and found myself napping across four empty airplane seats somewhere over Nebraska, my ultimate destination being the front of Mission Dolores at seven P.M.

The whole trip felt like a dream, a different dimension than my real life. The cooler air was a jarring disruption from reality. I call San Francisco the Land of Eternal Fall the way most Latin American cities call themselves the Land of Eternal Spring. I arrived on a cool night, wearing turquoise tights and leather boots.

And the activities in San Francisco were also out of the ordinary to me in just about every way. For example, I went *hiking*. Listen, it takes a *lot* to get me hiking. Like, you basically have to drag along an entire pot of coffee and a bagel the size of my face and promise me dessert afterward. So I went hiking, and lo and behold, I ended up discovering the activity's benefits. Mainly, if you start walking the lush, crooked trails of Mount Tamalpais early enough, the fog below peels back and reveals the ocean right when you get to the top. At first you can't even tell it's water; it looks like a solid sheet of cobalt stone all the way down at the bottom of the slopes. That is, until the sun finds its way through the fog to the waves. My San Franciscan love interest asked me if the view had been worth it; I said yes. Very, very much so.

During most of those chilly, blissful August days, I felt like I was watching someone else's life. There was one moment, however, in which I felt so present with all my thoughts, each contained in my body. I stood next to the window after a post-brunch nap, and looked outside for a long time, my gaze skimming over the rooftops and palm trees to the farthest point I could see—the early stages of a sunset in the distance. It was a rare sort of moment when two alternate universes suddenly collided—my life in Washington, D.C., and the life I could have been living in San Francisco.

CHICAGO, ILLINOIS

AND ALL THE JOBS I HAD THERE

TAUGHT GYMNASTICS TO SOPHISTICATED 4-YEAR-OLDS

LIVED IN a PINK STUDIO THAT WAS FAR FROM EVERYTHING EXCEPT THE LAKE

FELL IN LOVE WITH CHOCOLATE CROISSANTS AND MY IRISH POET COWORKER

WOKE UP aT 4AM TO MAKE COFFEE FOR CONSTRUCTION WORKERS

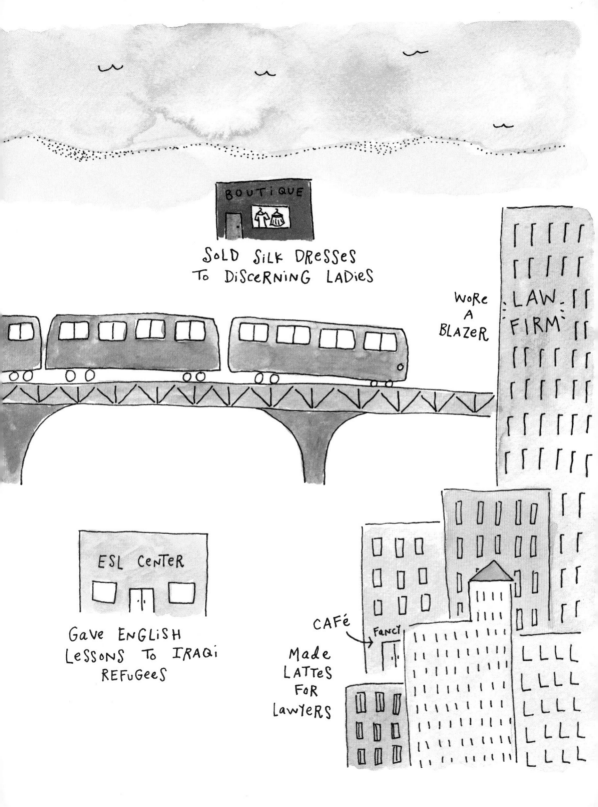

BOUTIQUE

SOLD SILK DRESSES
TO DISCERNING LADIES

WORE
A
BLAZER

LAW
FIRM

ESL CENTER

GAVE ENGLISH
LESSONS TO IRAQI
REFUGEES

CAFÉ

Fancy

MADE
LATTES
FOR
LAWYERS

PackinG To MeeT YouR LoveR

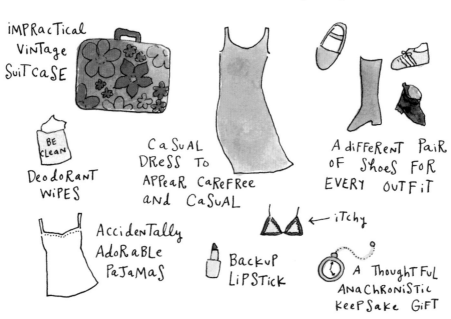

iMPRacTical ViNTage SuiTcaSE

BE cLEAN

DeodoRanT WiPES

CaSuAL DReSS To APPeaR CaReFRee aNd CaSuAL

A diFFeRenT PaiR oF ShoeS FoR EVERY OuTFiT

AccidenTally AdoRaBLe PaJaMaS

BackuP LiPSTick

← iTchy

A ThoughTFuL ANaChRoNiSTic KeePSake GiFT

I had originally planned to move to San Francisco. I thought about moving there again and again, but I never did. Finally, during that trip, I thought, *Perhaps I can fight fate and take matters into my own hands. Perhaps I can choose now.* There were some really good reasons to move, and even practical reasons to move, and reasons that were neither good nor practical.

The open window ushered in the mismatched smells of the sweet breeze and the smoke from a nearby burrito kitchen. I realized I had a choice: to be in this moment either as a visitor or as an inhabitant. I could either choose for this to be my summer—this paradise of morning sweaters and golden afternoons— or this summer could remain my alternate reality. My choice of D.C. over San Francisco came down to financial logistics, but I suspect that some fear crept into the pro/con list as well. At that point I prioritized the career I hoped to find and stability that seemed far from my reach. It felt too indulgent to value a sweet breeze over the promise of an entry-level job that provided insurance.

By moving to Washington, D.C., a few years after college, I said no to many alternate lives. I don't obsess over them, but I do think about them from time to time. In fact, some day I would like to check in on these lives, then contentedly go back to my true life and enjoy all of it in its imperfect, surprising splendor.

When I returned to summer on the East Coast, I was still delighted to feel a little cold in the morning, until I remembered that it was my air conditioner on the lowest setting and I wouldn't be needing a sweater after all. It was already hot at eight A.M., so I prepared myself for my increasingly uncomfortable walking commute. I wasn't sure I'd ever get used to summer storms or humidity, and I still thought fireflies looked like an optical illusion. Most seasons in Washington, D.C., are pretty standard fare, but summer is an exotic beast that I'll never domesticate. It will always shock me in small and sublime ways.

On days like this one, I think about the Other Me in the alternate universe that is a San Francisco summer, the summer I almost chose. It's a tame, well-mannered house cat of a summer. A summer that comes out in the morning, naps in the afternoon, retires early at night. Not anything like this raging East Coast monster that won't sleep until melancholy mid-September. I think about what that Other Me might be doing in her San Francisco life. Perhaps hiking is the norm for her now. Perhaps she has the svelte muscular body of a regular hiker! (Best-case scenario, of course.) It's possible Other Me is lonely. It's possible she is the happiest she's ever been. It's possible she has no job, or a job she hates, or her dream job. It's possible she is sitting next to that same window with the palm tree view, drinking whiskey, listening to romantic guitar ballads that come from the neighbor's living room downstairs. It's even possible she is missing the East Coast heat and its wild nighttime storms.

But when I was standing there, smelling the ocean-soaked air and watching palm fronds do the salsa in the salty summer evening breeze, all those possibilities came alive.

My Californian friend jokes that Midwesterners "stay there because they don't know winter is optional." But I discovered that summer is optional, too. I had a chance to choose a breezy, summerless year, and I didn't take it. The frustrating thing about making a choice is that you never know what the alternative would have been like; I can only squint to imagine what Other Me in San Francisco is doing while Real Me wilts in humid Washington, D.C.

By choosing summer, however, I chose the rest of the year, too: its fall, its snow, its new friends, its job that rekindled a passion, its trips up and down my beloved East Coast, its many nights of dancing. I chose summer and I will choose it again.

ALTeRNate LiveS

DANCe TeACHeR
iN RHoDE ISLAND

PLaNT- BASED
YoGA TEACHeR
iN San FRANCiSCO

MARRiED To
3RD BOYFRiEND
AND LiViNG iN THE
CHiCAGo SUBURBS

"DESiGNER"
iN MoNTREAL

FASHioN WRiTER
iN NEW YORK

LAWYER
(A REAL THiNG
I CoNSiDeReD)

DeciSioN

PROs	CONs
It will SouND FaSciNaTiNG at a HiGH ScHooL ReuNioN	- I'LL Have To MeeT a LoT oF NEW PeoPLe
- Social Media ANNouNCeMeNT WiLL Be GooD	- I'LL HAve To ExPLaiN DeciSioN To PeoPLe Who WoN'T uNDeRSTaND
- It wiLL uPSeT MY DAD	- It wiLL uPSeT MY MoM
- I'LL GeT To BuY ALL New CLoTheS	- I'LL Have To BuY ALL New CLoTheS
- It's ExciTiNG	- It's ScARY

CHAPTER 2
CReaTiNG HoMe

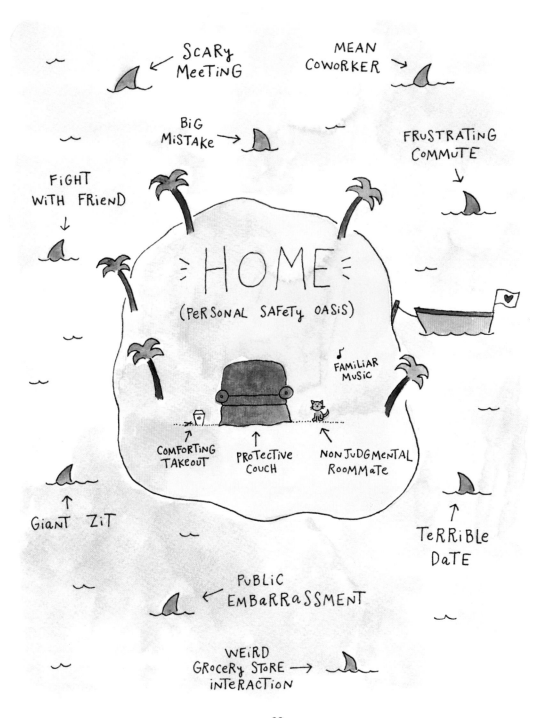

MOVING TO a NEW CiTY

HELLO, WORLD! I'M READY FOR WHATEVER YoU MaY THROW AT ME!

SPLaSH!

THiS PLaCe iS GoiNG To EAT Me ALive.

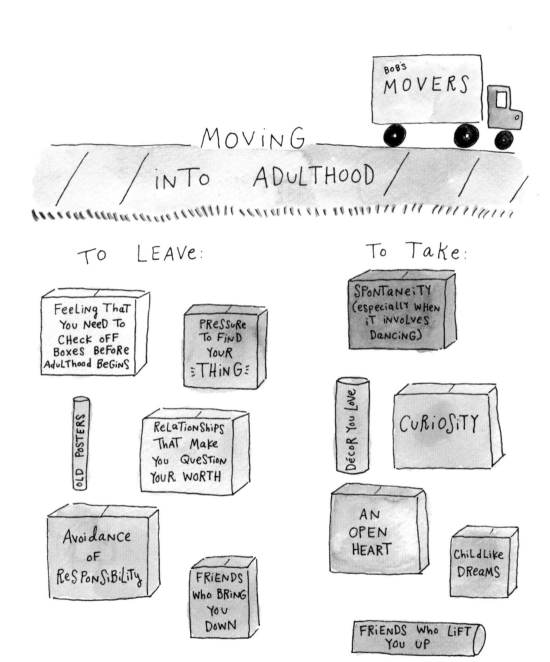

MOVING INTO ADULTHOOD

BOB'S MOVERS

TO LEAVE:

Feeling That You Need To Check off Boxes BeFore Adulthood Begins

PRESSURE To FiND YouR THING

OLD POSTERS

ReLaTionShiPs THaT Make You QuesTion YouR WORTH

Avoidance oF ResPonSiBiLiTY

FRiENDS Who BRiNG You DowN

TO TAKE:

SPoNTaNeiTY (especially WHeN iT invoLveS Dancing)

DécoR You Love

CuRiosiTY

AN OPEN HEART

ChildLike DReaMS

FRiENDS Who LiFT You UP

MOMENTS of VULNERABILITY
IN A NEW CITY

WORKING ON IT!

Application
Name:
SS:
$:

HAILING a CAB ONLY TO BE REJECTED, THEN PRETENDING YOU'RE JUST SCRATCHING YOUR HEAD ON THE CURB

Having TO STATE YOUR INCOME ON AN APARTMENT APPLICATION

INCONSPICUOUSLY READING THE SUBWAY MAP

PLease LIKE ME!

I WENT TO CATS BAR LAST NIGHT!

You AND A BUNCH OF COLLEGE KIDS?

IS IT 8TH AND 32ND, OR 32ND AND 8TH?

GOING ON FRIEND DATES

ACCIDENTALLY BRAGGING ABOUT UNCOOL ADVENTURES

PLAYING IT COOL WHEN YOU GET AN ADDRESS WRONG

LiviNG ALoNe

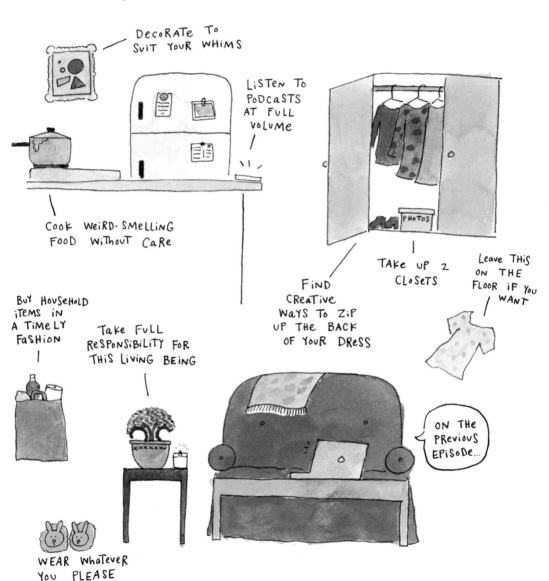

DecoRaTe To SuiT YouR WHiMS

LiSTeN To PoDCaSTS AT FULL VoLuMe

Cook WeiRD-SMELLING FOOD WiThouT CaRe

FiND CReaTive WaYS To ZiP UP THe BACK OF YouR DRESS

PHoToS

TAKe uP 2 CLoSeTS

Leave THiS oN THe FLooR iF You WANT

BuY HouSeHoLD iTEMS iN A TiMeLY FaSHioN

TAKe FuLL ReSPoNSiBiLiTY FoR THiS LiviNG BeiNG

ON THe PReVIOUS EPiSoDe...

WEAR WhaTeveR You PLEASE

HoMe

Cities are really just a bunch of small towns lumped together, connected by trains that run underground or sometimes above it. Mount Pleasant is a particularly small-towny neighborhood in northwest Washington, D.C. It has a cute, small-towny name, a small-towny square, and even small-towny people who would make for a charming opening-credit montage in a drama about a bunch of lovable characters just trying to make it in the city. Let me introduce you:

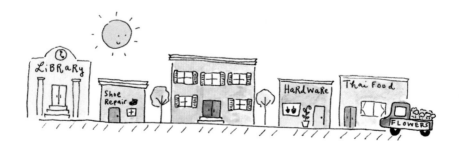

Avocado Sorceress

The Avocado Sorceress is a modern sibyl who understands the fickle quiddity of her tiny domain: a pile of avocados she attentively guards behind the counter at the international market. She asks only how many you need and when you will need them. You can get as specific as 6:27 P.M. and she will select the ones whose interior will ripen into buttery green just in time for dinner.

Radio Bicycle Phantom

I've never seen him, but I know he exists. The Radio Bicycle Phantom rides around the streets of Mount Pleasant with an ancient boom box that's strapped to a rack on the back wheel. It's almost always playing Michael Jackson. He unwittingly soundtracks my commute, my solitary dinners, and my creation of my home in this neighborhood.

Grumpy Baker

Who did this to you, Grumpy Baker? Who gave you that premature set of wrinkles on your forehead and that roughness in your voice? Do you dream of setting your apron aflame and investing in your dream career? Well, we wake up and look forward to sitting at one of your tables with a mug in front of us, journaling about our own sacrificed dreams and often unwanted realities. But the ordinary magic of your bagels significantly lessens our pain.

BRoCCoLi TRoUBadoR

It's really easy to fall in love with someone about whom you know nothing. I imagined his name to be Sebastian. He left the gypsy jazz scene in Paris with only an aging upright bass to jump trains and hitchhike, recording his adventures in a pocket journal filled with half-French scribbles about whiskey-warmed nights in Memphis and impromptu hikes in Portland. His seasonal job is to sell broccoli at the Mount Pleasant Farmers Market to pay for his ticket to Montreal, where he'll record his first jazz album. He knows about none of this.

PaRK TeeNaGeRS

I hear the same complaints over and over again about Washington, D.C.: "There's no culture here, no style! Everyone is obsessed with their careers!" To this, I say: Go to the park on a late afternoon, when the high schoolers are just released from school. They wear hot pink backpacks and ride neon blue bikes. They skateboard, play the guitar, choreograph dance routines to be recorded on a phone. They want to be artists or teachers or lawyers or fashion designers, but they don't just talk about careers. They support local businesses without using the word *locavore*. Their culture, though it is skipped over by double-decker bus tours, is distinctly D.C.

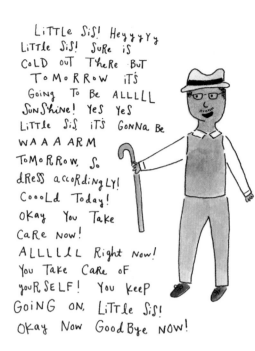

LiTTLe SiS! Heyyyyy
LiTTLe SiS! SuRe iS
CoLD ouT TheRe BuT
ToMoRRow iTS
Going To Be ALLLLL
SunShine! YeS YeS
LiTTLe SiS iTS GonNa Be
WAAAARM
ToMoRRow, So
dReSS accoRdinglY!
CoooLd Today!
OKay You Take
CaRe Now!
ALLLLLL Right Now!
You Take CaRe oF
youRSELF! You keeP
GoiNG ON, LiTTLe SiS!
OKay Now GoodBye NOW!

MR. EDDiE

I usually catch him in the lobby of my apartment building as I'm checking my mail. He tips his hat, tells me a joke, and goes on his way. I am always left smiling. Mr. Eddie is more than just a Mount Pleasant cast character; his presence is a miracle in my daily liturgy.

Mr. Eddie has an elegant approach to life. He prioritizes classic etiquette, most clearly evidenced by the fact that every single day he is decked out in a three-piece suit with a church hat and mahogany cane. He works the night shift somewhere, but in the afternoon, he shuffles down our street in glistening white oxfords, tipping his hat and giving the weather report. He talks like an old-timey radio announcer, or maybe a Southern preacher, elongating consonants and piercing his vowels. He always greets me: "Little Sis! Heyyyy, Little Sis! Sure is cold out there but *tomorrow* it's going to be *alllll sunshine!*"

One Friday morning, I heard someone screaming from the floor below me. The screams got louder and louder and then were joined by a clanging fire alarm that reminded me of my elementary school's dismissal bell. Then a man's voice: "Get out of the building!" followed by shouts of *"FIRE!"*

I don't remember getting out of bed or putting on a coat or running down the fire escape ladder on the side of the building, but I do remember seeing smoke billowing out of the windows as soon as I got down on the ground. I began coughing and wheezing—I had never given smoke much credit before that moment. It was a destructive by-product of burning plastic, paint, gas, and metal. The fire escape was quickly engulfed by a toxic cloud of it.

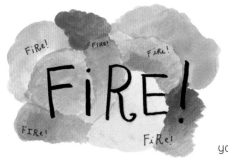

I joined my neighbors at a deli across the street from the building. We were already sharing our tales of escape when we were interrupted by an old man who came in, panicked. "Sorry to bother you all, but my friend Mr. Eddie lives in this building and he can't walk very well—have you seen him? Is he okay?"

We all looked around, our hearts plunging in unison. We realized we hadn't seen him—and worse, we hadn't noticed. We asked firefighters about the man with the cane in unit 207; they didn't know, either. They seemed as panicked as we were, rushing into the deli every half hour to count heads and then back into the building, still engulfed in black smoke. They gave us quick, disturbing updates: our landlord burned his hands, they were still looking for the dog, a room had collapsed. We attempted jokes to cut through the intensity and bought one another coffee to bolster the feeling of community. How easily you forget you're wearing your pajamas in front of forty strangers when the threat of loss is so acute.

Five hours huddled together passed quickly, even without our phones. We listened to our story on the local morning radio, and watched commuters come in for breakfast sandwiches, trying to make sense of all the people in bathrobes crowding the aisles of their deli.

A firefighter came in with one last update, giving us instructions to take a bus to the nearest shelter. "And, oh yeah," he added, "I know a lot of you were worried about your neighbor Eddie—he's with us and doing fine." We sighed with relief, and suddenly my memories of sweet exchanges with him felt like my most treasured memories. It was the first time I realized I was in love with my life here—the life I'd built for and by myself.

I'd had such a good feeling the day I went to go see that apartment in Mount Pleasant for the first time. The empty unit was filled with natural light and delightful quirks like a charming little door that opened to a fire escape where I planned to start an herb garden and watch movies on my laptop in the summer. I signed the lease without even seeing anything else on the market. The apartment became my refuge, my creative oasis—my favorite place to be. And now it was disappearing in smoke.

A week later, as the weather turned chillier, I went back to try to get my coat. A lightbulb dangled by a fat orange wire in the lobby. An inch of water

soaked the tile entrance. The walls were blackened and the halls smelled like poison.

I pushed open my door slowly to find a few men working in my apartment, wearing paper surgical masks. They tromped around my hardwood floor in muddy boots, ripping soot-covered posters off the walls and adding them to a big pile in the middle of my room. I looked closer and saw my pillow, my bookshelf, my drawing pens, a pink Valentine's Day card from my mom that I kept on my desk—the contents of my life.

"Who are you?" one of them demanded.

"I live here? I just need to get something?" I answered like I was asking.

"Oh. Okay. Well, just step around this stuff." He gestured to the pile.

"This stuff" was evidence of the life I'd created in the midst of dating woes, long-distance friendships, and job anxiety. I didn't have the career track many young Washingtonians did, but I had this little refuge in a wonderful neighborhood, and a meaningful relationship with the kind, well-dressed old man who lived in my building.

In my early twenties, I sought extremes of pain and ecstasy that gave me fuel for journal entries and a reason to revel in drama and sad music. I thought that meaning only existed in these intense, forceful places. But the fire showed me the beauty of the middle, everyday place. I ached for the mundanity of slipping the tiny metal key into the copper mailbox and hearing Mr. Eddie's weather report. I wouldn't take the mundane for granted again.

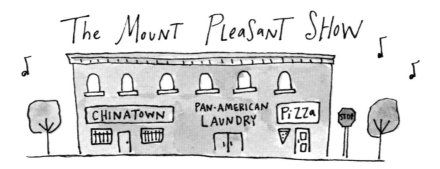

WaSHiNGTON, D.C.

CRiED oN THiS STRaNGeR PoRCH

LoTS oF GOOD MURALS UP HERE

THe VERY DiGNiFiED NaTioNAL CaThedRaL

I LoVe THiS LiTTLe CANDLeLiT BAR FoR DATES WiTH MYSeLF (I LiK NoT HaviNG To SHARE THE CALAMaRi)

SHoe RePAiR

STOP

RUNNiNG TRAiL

HOME

MY APARTMENT BUiLDiNG ♥

MY CoMMuTe

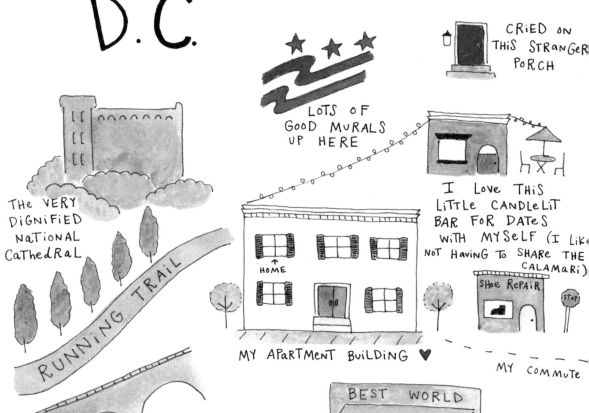

BEST WORLD SUPERMARKET

2¹⁹ 3⁶⁵ 5

THiS BRiDGE iS A GooD SPoT To oBSeRve The SeaSoNS CHaNGiNG.

A BENCH FoR SERiouS TALKS

OUR TOWN SQuaRe: The iNTeRNaTioNaL GRoCeRY SToRe, WHeRe NeiGHBoRS MiNGLe iN THe SPiCe AiSLe.

CoFFee

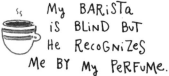

My BARiSTa iS BLiND BuT He RecoGNiZeS Me BY My PeRFuMe.

I usually WEAR ALL BLACK ON DATES.
↓

Dive BAR FOR FIRST DATES

SHERRY & HAM

HIGHLY SPECIFIC TRENDY BAR FOR SECOND DATES

COZY JAPANESE RESTAURANT FOR THIRD DATES

CAFÉ

COFFEE SHOP FOR TAKING iT DOWN A NOTCH

COCKTAILS

AN OLD MAN and HiS wiFe DRiNK WiNE ON THEiR PATiO EVERY WARM EVENiNG

MYSTERIOUS GARAGE FULL OF PLANTS

NOCTURNAL STREET:

21+

JAZZ CLUB

UNDERGROUND DANCE FLOOR

LOUNGE OPEN Till 4am

D.C. ROWHOUSES ARE PAINTED THE COLORS OF GUMMY CANDY and THE SUNSET.

BEST PLACE TO SEE A MOVIE SOLO. I LiKE TO BRiNG iN MiNi WiNE BOTTLES and SHARE WiTH OTHER SINGLE GALS.

HOUR-LONG WALK AND iT iS THE BEST PART OF MY DAY.

FBI SOUVENIR SHOPS

CHAIN SANDWICH STORES

CHIPS

SO MANY TiES!

SALSA CLUB

I OFTEN FORGET THE WHiTE HOUSE iS HERE and ONLY REMEMBER WHEN i SEE A BUNCH OF FAMiLiES TAKiNG PHOTOS.

TRno BERLIN

My OFFICE iS ACROSS THE CiTY AND FEELS A WORLD AWAY.

The PROCESS of CREATING YOUR OASIS

EVEN iF you HAVE ROOMMATES, YOUR OASIS iS ≡YOURS≡

iT CAN BE ONE NICE CHAIR THAT iS ALL YOUR OWN

IT ReFLeCTS WhAT ≡YOU≡ LiKe, NoT WhAT YoU ThiNK YoU SHOULD LiKe

 IT iS SAFe

Check YouR SMoke DeTeCToR oNCe a MoNTH!

AND COZY

A LiTTLe CANDLe GoeS A LoNG WAY

AND COMFoRTaBLe

DRESS CoDe: PJs

HOME SWEET HOME

AND To aN ENTiRe CiTY

FavoRiTe TRee

FavoRiTE CoFFee SHOP

FAVoRiTE DRY CLEANER

IT CaN EXTEND To YoUR NEiGHBoRHooD

The STAGES OF BECOMING AN ADULT

STAGE 1

DORM FURNITURE

STAGE 2: WhaTeveR You CaN GeT

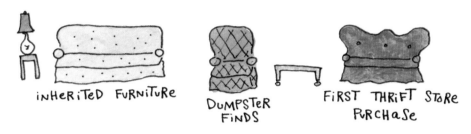

iNHERiTeD FURNiTuRe

DUMPSTER FiNDS

FiRST THRiFT SToRe PuRCHaSe

STaGe 3: AFFoRDaBLe DIY FuRNiTuRe

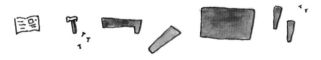

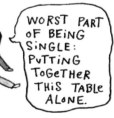

WORST PART oF BEiNG SiNGLE: PuTTiNG ToGeTHeR THiS TABLe ALoNE.

STAGe 4: WHAT YoU ACTuaLLy WaNT

BRAND-NEW PLuSHY CouCH (iN "SoFT SAGE")

CooL ANTiQue

DePaRTMeNT SToRe BED

CuSToM PiECE (wow)

THiNGS I'D RESCUE iN A FiRE

THE BRONZER
That You CaN
oNLY GeT FROM
THAT MALL iN
THE SuBURBS

The LaST DROPS
oF FavoRiTe
PERFUMe
($1,000 PeR
DROP APPRox.)

The oNLY
I.D. I Have
WiTH a FLaTTeRiNG
PHoTo

ExPenSive
SPice I BoUGHT
FoR oNe ReciPE

PiLLoW THAT iS
THE PeRFECT
FiRM- SQuiSHY
ComBO

PLaNT I've
ManaGeD To KeeP
ALive FoR a YEAR
(a MiRACLe PLaNT)

AN iMPoRTaNT
STicky NoTe

MoST
FLaTTeRiNG
JEANS

TEXT
MESSAGe
MachiNE

A Piece
oF
JeweLRY
WiTh a SToRY

Avocado THAT
⫶ JUST⫶
GoT RiPE

· 44 ·

WHEN A NEW CITY
FeeLS LiKe HoMe

THE FiRST TiME
You Make The RiGHT
TURN WiTHOuT THiNkinG
ABouT iT

WHeN The BARiSTA
SeeS You iN LiNe AND
GiVeS You A NoD
OF ReCoGNiTioN

You WRiTE YouR
ADDReSS WiTHouT
THiNkiNG ABouT
iT

WHeN GoiNG ouT
iNTo THE CiTY iS
AS COMFORTABLE
AS STAYiNG iNSiDE
BECauSE THeY ARE
BOTH HOME

WHeN You ReTURN
FROM a JouRNeY
AND iT'S A RELieF

WHeN You FiND
YOUR PLACE

ChapTeR 3
FINDiNg PURPoSe

CHOOSE ONE:

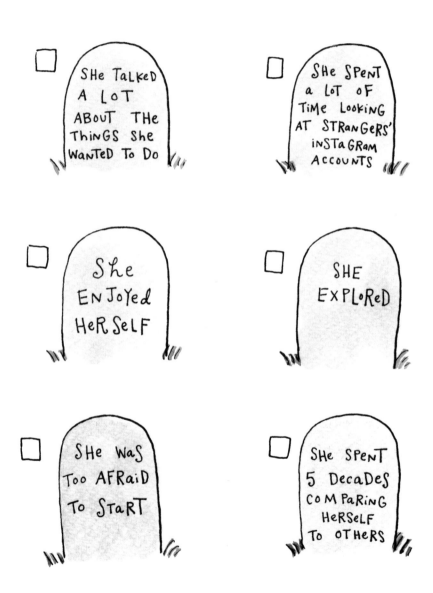

☐ SHE TALKED A LOT ABOUT THE ThinGS She WANTED To Do

☐ SHE SPENT a LoT oF TIME LooKING AT STRANGERS' inSTaGRam ACCOUNTS

☐ She ENJoYed HeR SeLF

☐ SHE EXPLoReD

☐ SHE WaS Too AFRaiD To STaRT

☐ SHE SPENT 5 DecaDeS CoM PaRinG HeRSelF To oTHeRS

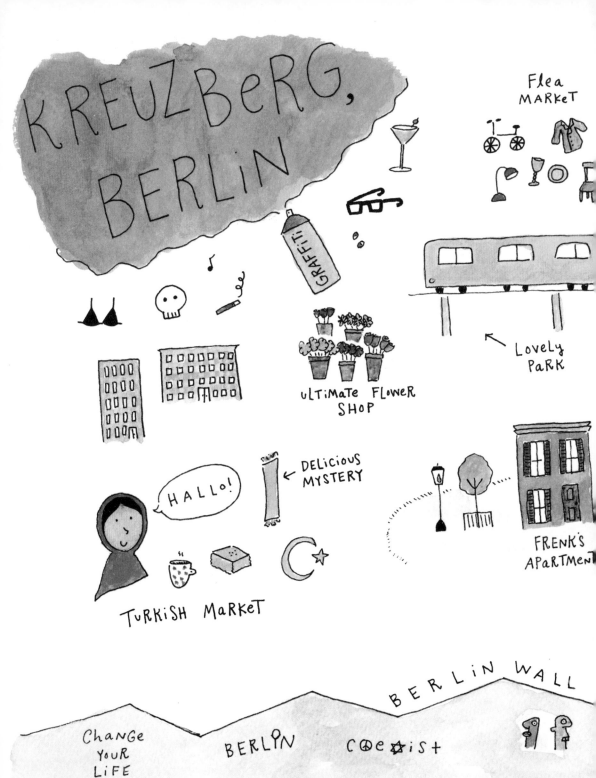

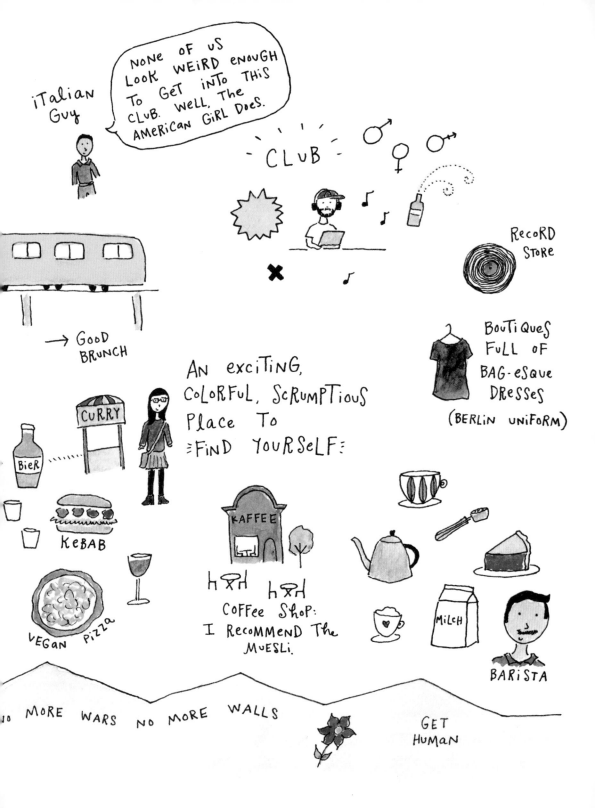

The Tilda Swinton of Cities

OcToBeR iN BeRLiN

It had just stopped raining the afternoon I arrived in Berlin.
I was supposed to land in the morning, but the flight had been
delayed several hours for who knows what reason. A cab
through the city was my last leg of the journey, and in the
quiet afternoon, the streets all shared a gray tint that reminded
me a lot of my hometown of Seattle: cerebral and murky.
It was exactly as I had imagined it.

As a teenager, I would have had zero interest in going to Berlin. But then (and this is seriously what happened), I was wearing a sparkly skirt with a polka-dot sweater and fringed scarf one spring day, and an old lady stopped me on the street and told me, "You have style! You look like you belong in East Berlin!" So I saved up money to go that October, because I imagined fall would ignite the city with opulent color and melodrama. I envisioned Berlin as dark, moody, and elegant—the Tilda Swinton of cities—and predicted that October would bring out its theatrical qualities.

I stayed in an apartment in Kreuzberg, a neighborhood that used to be cool in the '80s and is now cool in a throwback way, like button-fly Levi's. Kreuzberg

is a tawdry mess of baklava shops, skateboard stores, and smoke-filled night-clubs. The wildest parties begin when some people are waking up and often end in the afternoon, when kids who have just discovered grunge music stumble out onto the sidewalks and merge with Turkish immigrants who established Kreuzberg as their home in the '60s.

I'm eager to slip into routine when I'm traveling. At home, I try to mix things up, wander, explore, remain a new stranger in my chosen city. Abroad, I'm in a rush to belong. I immediately claim a café, a bar, a route home. At the end of the week I casually mention *my* barista, *my* subway line—and I mean it. When a day in a foreign country feels comfortable, or even a little boring, that's when I'm able to dwell in my beloved middle place where I can find beauty in the subtleties of the city. Within a week, I know my neighbors and I know the way the light hits the tile of my kitchen at four P.M.

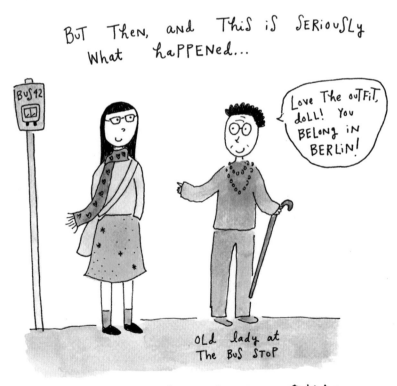

BuT TheN, and ThiS iS SERiouSLy What haPPENed...

Love The ouTFiT, doLL! You BELoNg iN BERLiN!

OLd lady at The BuS SToP

... So i waS Like, WELL, OKAy.

FRENK

Likes: Collecting Maps,
Clubbing (but only
till 3am),
Small ceramic dishes,
Large indoor plants,
The placid countryside

Dislikes:
Goldfish maintenance,
Nazis

Like many people, before I visited, I thought of German as an inhospitable, harsh language because I had only really heard it in the context of screaming Nazis in movies. When it's spoken for the gentle purposes of ordering baklava or offering directions to the soul and funk record store, it's as romantic as poetry read aloud. But the city is the strong, silent type. The city and I got to know each other through a series of nods, smirks, and nonchalant stares. Spending time alone in a new place brought me to new corners of myself.

I skipped most tourist attractions in favor of taking long walks, but I was set on seeing the Holocaust memorial, and did so my second day there. It was a perfect fall afternoon: the light was gold and looming shadows were periwinkle. The memorial is a huge field with about three thousand coffin-like concrete blocks. As you walk through the blocks, they grow taller and you begin to feel claustrophobic. Even on a beautiful afternoon, you feel like you are walking into the night. The light's once romantic glow begins to look eerie. And eventually, you lose the light completely.

But then you come out the other side. You realize it is the same afternoon it was just moments before. There are school kids sitting on one of the shorter blocks, sharing pretzels and texting.

I sat for a long time at the edge of the memorial, disarmed by the beauty of the day. The kaleidoscopic light illuminated the surrounding trees the cheerful color of sweet potatoes. Warmed by lunchtime beer and the fleeting sun, I was so happy to be alive that day. I was so happy to have that day.

It was impossible not to think about how the victims of the Holocaust had also had lives. I thought about the things they must have experienced before. When they were young, they went to school and took notes on thin paper about geography. Sometimes they probably looked out the window, wondering about things like adventures and God and kissing and what their face was going to look like when they were old.

THROUGHOUT THE DAY,

WARM PRETZELS WITH CRUNCHY FLAKES
OF SEA SALT

 SPICY CURRIED SAUSAGE

SQUARES OF MILD CHEESE

SLIVERS OF RASPBERRY CAKE

VERY SENSIBLE
PORTION

BEFORE NOON: COFFEE

AFTER NOON: WINE

KAFFEE,
BITTE (MOST
IMPORTANT
ROTWEIN, GERMAN
BITTE PHRASES)

A few years later maybe they sat on red velvet cushions in the back of the movie theater with someone they liked a lot, feeling like their nerve endings might explode into stardust when they held hands with that person.

They wondered if they had achieved anything, if they ever would.

This was the first time it occurred to me that I was not immortal, and the first time I realized just how much I enjoyed living. Not because of triumphs and trophies, but because of things like pressing elevator buttons, wearing a sweatshirt and making pancakes on Christmas morning, finding a seat on a crowded subway, reading on trains, whispering when there was no need to, and watching a cat clean his ears with his paw.

Throughout my early twenties, I had been so anxious about *finding my purpose*, as though it were buried treasure that would be waiting for me if I followed the clues and happened upon the right place to start digging. I looked around and saw other people my age who seemed to have found theirs, and tried to analyze their treasure maps: *Will I find it in grad school? At a nine-to-five job? In another city?* I thought that once my career clicked into place, my life would start making sense. I'd have a purpose.

My feet dangled over the edge of the concrete block and I watched the leaves wiggle with the breeze. What kind of happiness and fulfillment was I chasing that I didn't have in that moment? Suddenly, my purpose didn't feel quite so elusive. What I love most about living isn't accomplishing things, but experiencing them.

The experiences I treasure from my twenties are seeing envelopes containing handwritten letters through my copper mailbox, kissing on an East Village sidewalk, beginning my Friday nights at my weekday bedtime, having mimosa brunches with my mom on lazy Saturdays, finding a house painted like a watermelon in the middle of Washington, D.C., on an otherwise melancholy evening.

These are my achievements.

I've decided a tombstone that reads "Here lies Mari: She enjoyed herself" would be an extraordinarily fortunate accomplishment. From now on, my life lived will be my life's work.

My last day in Berlin could have been frantic, trying to squeeze in every last "should do" before I left the city. Instead, I took it slow, dawdling around a neighborhood I'd already covered the day before. But this time I stopped in to every shop that caught my eye, and took a long while to finish my waffle. I gave up my plans to conquer a museum, and instead found a wealth of local modern art in an art supply store where everything inside was handmade in Berlin, down to the erasers. I talked late into the afternoon with the illustrator

OTTiLie

A Chic, STORied SPeciMeN

who owned it and whose sketches lined the walls.

"Are you an artist?" she asked me. I was a little embarrassed, as though she were going to ask to see my official artist license before she would sell me anything. "Not at all." I laughed. "I mean, I doodle sometimes, and I like pens."

She told me that she started drawing as a hobby at my age simply because it was fun; she didn't go to art school. She didn't start drawing with any career intention. I told her how radical this seemed to me; I didn't feel like I could just begin a new hobby at this stage without a guaranteed résumé line implying that it may be *my purpose*.

"I didn't put a pen to a paper because I thought it would turn into my job," she replied. "I'm not even very good! I just always liked it." She spoke about art as though she were talking about her best friend or a bubble bath. She wasn't creating for accolades, but for the satisfaction of a new paintbrush dipped in fuchsia.

Maybe I'll try art for myself one day, I thought.

My last night I had exactly four euros left, and spent them on espresso at a French restaurant. People kept coming in from the rain, all sorts of interesting characters filling the barstools. I watched an older man sit down to do a cross-word puzzle with blue ballpoint on smudged newspaper, his black bowler hat covering his gray, caterpillar-like eyebrows. Sipping from a mug heavy with whipped cream, he looked as content and comfortable in his life as he did at this bar. I pulled out my sketchbook and hoped I did, too.

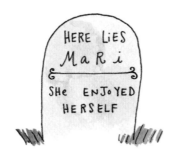

HERE LiES
MaRi
SHe ENJoYED
HERSELF

PEOPLE WORTH ADMIRING

QUESTIONS TO ASK

STYLISH OLD Lady DOING HeR OWN THING AND HaViNG a GREAT TiMe

How did SHe GeT

FRiEND Who NeVeR MaKeS You FeeL BAD ABoUT YouR CHOiCeS BeCauSe SHe iS CoNFiDeNT iN HERS

How DiD

FicTioNaL CHaRacTeR WHo DOES THE RiGHT THING

How Do You BecoMe

WoMen Who AReNT AFRaiD oF a BoLD HaiRCuT aND a BoLD LiP

WhaT'S HeR

KiDS Who ARE JAZZED ABoUT LiFe

How CaN

PROBABLE EXPLANATIONS

THAT WAY? _ _ _ _

She took on the WORLD ALONE.

SHE GET THAT CONFIDENCE? _ _ _ _ _ _ _

BONJOUR!

She took ALL The RISKS SHE WANTED.

DONATE VOLUNTEER

a PERSON who DOES The RIGHT THING? _ _ _ _ _ _ _

PRACTICE.

BACK STORY? _ _ _ _ _ _ _ _ _

SHE SPENT TIME GETTING TO KNOW HERSELF. NOW She KNOWS SHE LOOKS GREAT IN PLUM!

I Be MORE LIKE THEM? _ _ _ _ _ _ _ _ _

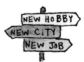
NEW HOBBY
NEW CITY
NEW JOB

FOLLOW YOUR CURIOSITY.

SoLo TRaveL TiPS

1. ASK a TeeNaGe GiRL To TaKe YouR PicTuRe – THey KNow THE GooD ANGLeS!

2. ASK aN oLD MaN FoR DiRecTioNS – HE KNoWS THiS CiTY!

HaS a MAP iN HiS HEAD

3. Make FRiENDS WiTH LocaLS WHo WoNT JuDGe YouR LaNGuaGe SkiLL S.

WOOF!

4. Make YouR DREAM oF a ⹂CHeeSe PLaTe FoR ONE⹂ CoMe TRUE.

5. Have a WHiRLWiND Love AFFaiR (WiTH YouRSELF).

PeRFUMe

Le ♥ ChiC

6. WATCH How oTheRS ASK FoR The CHECK.

DE REKENING ALSTUBLieft!

7. BUY ThiNGS To REMEMBeR ThiS SPeciAL TiME iN YouR LiFE.

8. Make FRieNDS WiTh The PEOPLE at THE NexT TaBLe.

9. FALL iN Love WiTh The BARTENDER (FoR REAL oR iN YouR HEAD).

10. You WiLL HaVe MoMeNTS oF exHiLaRATioN aND iSoLaTioN. PoST The PHoToS oF exHiLaRaTioN!

TRAVEL

EXPECTATIONS VS. REALITY

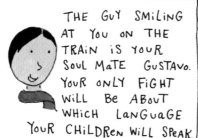

THE GUY SMILING AT YOU ON THE TRAIN IS YOUR SOUL MATE GUSTAVO. YOUR ONLY FIGHT WILL BE ABOUT WHICH LANGUAGE YOUR CHILDREN WILL SPEAK.

YOUR TRAIN COMPANION IS BOB, A BRITISH RETIREE WHO HAS A LOT TO SAY ABOUT CAPITALISM.

YOU WILL FALL IN LOVE WITH THIS CUISINE, ENJOYING EXTRAVAGANT DINNERS FULL OF MARVELOUS SURPRISES FOR YOUR PALATE.

YOU WILL FALL IN LOVE WITH THE FALAFEL MAN, THE ONLY ONE SERVING FOOD BEFORE 10 PM.

YOU WILL HAVE A SPIRITUAL BREAKTHROUGH AT SOME BEAUTIFUL HISTORIC SITE, FEELING VERY ≡ONE≡ WITH HUMANITY.

WHILE WAITING FOR THE HORDES OF TOURISTS TO LEAVE THIS HISTORIC SITE, A BIRD WILL POOP ON YOUR HEAD. THE SECURITY GUARD WILL SEE AND YOU'LL BOTH LAUGH, BECAUSE THE LANGUAGE OF HUMILIATION IS UNIVERSAL.

ThiNGS I DeFiNiTeLy DiD NOT NeeD To PACK

GiaNT CaMeRa:
The PhoNe SuFFiceD

The "JuST iN CaSe"
DRESS

RuNNiNG SHoES:
HA!

SCARF:
The MoST FuN
ThiNG To BuY
oN VacaTioN

A Book I
BouGHT 5 YeaRS
AGo: NoT
GoiNG To READ
iT NoW

THE CuTE LiGHT
JACkeT:
WHeN iS iT eveR
ExacTLY 68 DeGReeS?

NaviGaTing a FoReiGN Place

SCeNTS You'LL RememBeR FoReveR:

AN uNFamiLiaR PaSTRY

A NEW SEA

The CHiC WOMAN oN The SuBway WhoSe PeRFUme (OR iS iT SHAMPoo?) You'LL NeveR KNOW

A RooM THAT FeeLS LiKe HoMe WiTHiN 2 DAYS

POTeNTiAL Love iNTeRESTS:

PROBABLy a PoeT

BARiSTa WHO HoLDS The SecReTS To LiFe

BeauTiFuL HiPPie Who MakeS You ReTHiNK YouR whoLe WaRDRoBe

MySTeRiouS LoNeR AT THE CLuB

LoSSeS THaT WiLL CHALLeNGe You:

LuGGaGe

¿Qué?

WoRDS

SeNSe oF DiRecTioN

I ♥ PiSA

HEART

MoMeNTS ThaT WiLL ShaPe You:

FiNDiNG A FRieND

FiNDiNG LoVe

FiNDiNG PLeaSuRe

FiNDiNG HoMe

NaviGaTing YouNG ADULThooD

SCeNTS You'LL ReMeMBeR FoReveR:

YouR FiRST Love's DeoDoRANT | The Book You ReaD OveR AND oveR | The BASemeNT BaR | The CARPeT iN The Hallway oF YouR FiRST APaRTmeNT

PoTeNTiAL Love iNTeReSTS:

COWORKeR | BeST FRieND (could iT WORK?) | ONLiNe GuY (JeFF?) | GuY I SomeTimes iNTeRact wiTh oN TwiTTeR

LoSSeS ThaT WiLL ChaLLeNGe You:

KeYS | JoB | CeRTaiN DReamS | ChiLdHooD

MomeNTS ThaT WiLL SHaPe You:

FiNDiNG A FRieND | FiNDiNG LoVe | FiNDiNG PleaSuRe | FiNDiNG HoMe

TRaveLinG SoLo iS A LoT LiKe BeinG iN YouR 20s:

You Have an idea oF How iT wiLL Look. IT oFTen LooKS a LiTTle DiFFeRenT.

THiS iS WheRe YouR CReaTiviTy aND YouR GuTS CoME iN.

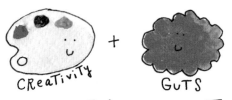

CReaTiviTy + GuTS

= uNexPecTed oPPoRTuniTieS SuRPRiSinG FRienDSHiPS uNFoRGeTTaBle ADveNTuReS

When You TRaveL ALoNe, ≥YoU≤ GeT To CReate YouR AdveNTuRe. BecoMinG AN ADuLT iS all aBouT CReaTinG YouR ≥LiFe≤ ADveNTuRe.

THE PROCESS OF FINDING YOUR PURPOSE

LOOK FOR SIGNS:

INSPIRATIONAL QUOTES ON INSTAGRAM THAT SUDDENLY SEEM PROFOUND

YOUR HOROSCOPE (IGNORE AN UNFAVORABLE ONE)

A BIRD (OPEN TO INTERPRETATION)

LISTEN TO ADVICE:

AN OLD LADY AT THE BUS STOP WHO HAS LIVED A LIFE

YOUR WISE ACQUAINTANCE

A PODCASTER WITH A SOOTHING VOICE

Make a DECISION TO IMPRESS ONLY THESE 2 PEOPLE:

YOUR 85-YEAR-OLD SELF

YOUR 5-YEAR-OLD SELF

TRY A MILLION JOBS:

WANTED: · JOURNALIST
· BARISTA · PRIEST
· TRAIN · TAROT
 CONDUCTOR READER
· CLOWN · ACCOUNTANT

SURE!

CHaPTeR 4

Love and DatinG

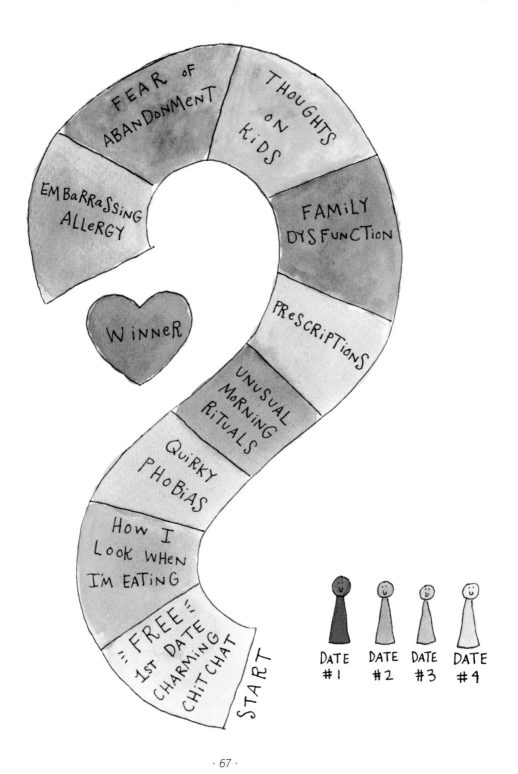

FEAR OF ABANDONMENT

THOUGHTS ON KIDS

EMBARRASSING ALLERGY

FAMILY DYSFUNCTION

WINNER

PRESCRIPTIONS

UNUSUAL MORNING RITUALS

QUIRKY PHOBIAS

HOW I LOOK WHEN I'M EATING

"FREE" 1ST DATE CHARMING CHITCHAT

START

DATE #1 DATE #2 DATE #3 DATE #4

SiNGLe LiFe

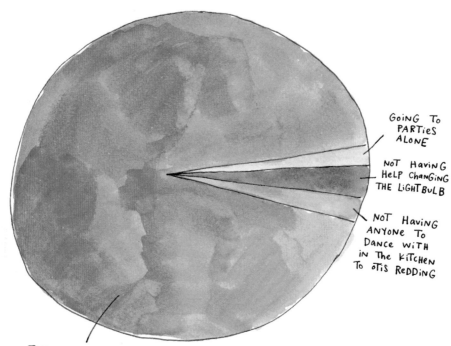

GoiNG To PARTieS ALONE

NoT HAVING HeLP ChaNGiNG THE LiGHTBULB

NoT HAViNG ANYONe To Dance WiTH in The KiTCHEN To oTiS ReDDiNG

FoReiGN Love AFFAiRS, PAD THai ALL To YoUR SELF, SPoNTANeoUSLY MoViNG To SPAIN

I WISH ALL DATES WERE AS EASY AS THE ⁚FRIEND DATE⁚

Hi! So Nice To Meet You!

You Too! But I Feel Like I ALREADY KNOW You!

The ONLY ANXIETIES ARE:
IS SHE COOL WITH HUGGING?
DOES SHE LIKE MY OUTFIT?

I Love YOUR OUTFiT!

I BROUGHT You A PRESENT!

You DON'T Have To WORRY ABOUT
⁚SEEMING TOO EAGER⁚

YOU ARE AMAZING!

LET'S HANG OUT NEXT WEEK!

FaLLiNG

In the two months before leaving my home of Washington, D.C., for a trip to Lisbon, Portugal, I had isolated myself. I had put on a pretty good show of keeping it together during grief and heartache, which mostly meant being alone. The vacation was supposed to be romantic, but became a solo trip when my boyfriend, Alejandro, and I had broken up a month before. The morning I arrived in Lisbon, I began to crave the opposite of isolation; I was ready to join the liveliest of life and I was most certainly ready to embrace my singleness.

On my last night there, I accomplished a lifelong dream of falling in love with a Spanish guitarist. He asked me my name before the last song in his set, "The Girl from Ipanema," strummed over a mesmerizing loop. Everyone in the courtyard restaurant lingered under striped umbrellas and the spell of this Brazilian wizard with Da Vinci angel hair and a furrowed brow.

He played in one of Alfama's palm-shaded plazas, where coral linens fluttered, collecting the smell of sea salt. My eyes chowed down on the colors

of Alfama's steep slopes. I got lost countless times in the twisting cobblestone labyrinth, only to discover new patterns of those iconic tiles, Technicolor flags strung from window to window, and crowded outdoor tables alive with wine bottles and the gregarious *zh-sh-ch* sounds of Portuguese.

That evening, I was on my way to the nightlife-fueled Bairro Alto. I thought it would be appropriate to end the week there, on the night that I had finally overcome my jet lag and remembered how to order a beer in Portuguese.

But I never could resist the Spanish guitar, which has led me to plenty of romantic disasters in the past. The guitarist was playing a familiar song as I passed through the area on my way out, so I stopped to listen for a minute.

A minute became two hours of calamari and the crepuscular transition from white to red wine. I wrote in my journal and chatted with the photographers at the next table, but the whole time, I was transfixed by the guitarist, whose passion punctuated every note. As the evening tumbled into night, I knew I wouldn't be making it to Bairro Alto.

I saw stars in the eyes of college girls, waitresses, and middle-aged tourists. I turned red when the guitarist focused on my eyes and asked across tables if I would like to go out with him after his set. Everyone turned around and looked at me. I stuttered, "Yes, I'd love that."

"Did Woody Allen write the screenplay for your vacation?" a friend asked me when I recounted this moment.

When his set was finished, we walked up one of Alfama's secret alleys to meet his friends for a back-of-the-bar jam session. More Nirvana, less João Gilberto. They traded off playing drums, guitar, and the triangle. Bohemian expats from Japan and England joined. We spoke a stew of French, Spanish, and English.

"I head back to the States early in the morning, so I can't stay out much longer." I'd later laugh at this statement as I fumbled with the skeleton key to my apartment door, wisps of sunlight just beginning to brush the blue and white porcelain tiles of my building.

I had wondered many times throughout the week how a place could stand to be so beautiful. It nourished so much life, from peacock flocks to webs of hibiscus, messes of gardenia and legendary swallows. *Does anything bad ever happen here?* I wondered earnestly, not out of resentment, but rather, in awe.

But of course bad things happen here. This land is haunted with a deeply sorrowful, often ugly history marked through time by the Crusades, colonialism, a dictatorship, and sudden poverty. As you happily lap up pistachio gelato, you can hear the gloomy melodies of fado, an entire musical genre devoted to

ON GuiTaR:
TePPe FRoM JaPaN

ON TaMBouRiNe:
SÉRGio FRoM BRaZiL

ON DRuMS:
KAi
FRoM
ARGeNTiNa

ON VoCalS:
NiNa FRoM
ENGLaNd

Portuguese-brand heartbreak and homesickness. Blossoming trees grow next to ancient prisons. Beauty tangles with grief.

As I said good-bye to my new friends on my last night, my heart was full and breaking at the same time. The guitarist identified this feeling: *saudade*. Ah, yes, the national word of Portugal.

They say *saudade* is unique to Portuguese, impossible to define in English. Nostalgia gets pretty close, but *saudade* is more complicated. It's the remnant of gratitude and bliss that something happened, but the simultaneous devastation that it has gone and will never happen again. It marries the feelings of happy wistfulness and poignant melancholy, anticipation, and hopelessness. It's universally understood by a cross-ocean culture with a constant feeling of absence, a yearning for the return of something now gone.

Each day at sunset, I ached over the romance with Alejandro that I deeply missed. I kept company with an abstract, incomplete version of him: his smile, his laugh, and one voice mail remaining on my phone. His apparition kept me company over the panorama of burnt tile rooftops cooling as the sun took its final bow of the day. Then the breeze would pass through and his apparition would go along with it, leaving me at a two-person table with one empty seat.

But any time of day besides the sunset, I recognized how much happier I was to be single, with every freedom belonging only to me. I thought about how well this freedom suited both my spontaneous whims and long-term desires, and I questioned, as I've been questioning for a long day, if I'm cut out for a relationship. I love to spend time alone, I love to travel by myself, I love the possibility of romantically connecting with a new beautiful soul at any given moment. How disappointed I would be to have to turn down, say, a Spanish guitarist.

I couldn't get over how different my night with him was from the string of mediocre-to-terrible dates I'd had recently in Washington, D.C. The guitarist's gentleness was disarming and he was so present—he didn't look at his phone once. In fact, I'm not even sure he had a phone.

The guitarist and I stepped out into the silent alley for fresh air, the sound of our footsteps amplified by stone. By the glow of street lamps, we found a place to whisper—under the archway of a thirteenth-century whitewashed chapel.

He asked me if I played guitar. I laughed. "No, my dad's a guitarist, but I didn't get any talent for it." I almost caught my use of the present tense, but let it go. My father's death was the last place I wanted to mentally visit, so I used magical thinking and my flawed Spanish—our common language—to pretend it hadn't happened.

I actively reclaimed the trip as one just for myself. I had packed only my favorite clothes to help me be the person I wanted to be on vacation; I could also bring only the loveliest parts of my life to be the person I wanted to be this particular evening.

When I'm on a good date, all the surrounding details conspire to enhance my adorability. The waiter laughs at my jokes and the strap of my dress slips off one shoulder just perfectly. A bad date, in contrast, makes me feel totally bland. It's hard to sparkle when a guy keeps yawning and blames it on not getting a long enough nap. Many couples have sighed to me over the years after hearing my tales of the bad ones, "Dating sounds so rough. I don't miss it at all." And, often, I agree—it can be rough. But a really good date will make all the unanswered texts and pre-dinner jitters worth it. It's like acting in a play where your role is the very best version of yourself, and you already know that the final line in the scene will be, "I'd like to see you again."

Even though I was certain I'd never see this particular man again, I chose to count this evening as a legitimate date—the best date of my entire twenties, in fact. When he asked what I did for a living, I caught myself off guard by replying without hesitation, "I'm a writer and artist." These were words I'd never truly claimed before.

"Of course you are," he replied. "I could have guessed that."

It didn't feel like a lie; it felt more truthful than the facts. This is the bonus of a good date: you find things you love about yourself when you're impressing someone else. Falling in love with someone else is a little bit about falling for yourself.

LISBON, PORTUGAL

Late-NiGHT CRUSH: GUy SelLiNG 2AM PiZZa SLiCES

EVENiNG CRUSH: BARTeNDER WHOM I TAUGHT To MaKE a NEGRONi

PARK CRUSH: ELeGaNT MAN THROWiNG a TWiG To HiS BEAGLE

SiDeWALK CRUSH: TRoLLEY DRiVER

BEACH CRUSH: ToWEL VeNDoR

MORNiNG CRUSH: BAKER CoVeReD iN CRUMBS

WATERFRONT CRUSH: GELaTo STAND OWNER

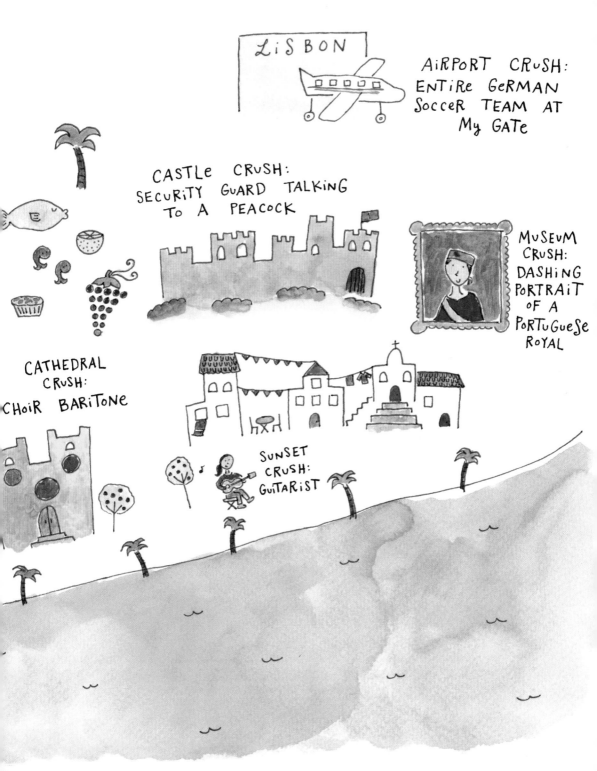

MODERN ROMANCE

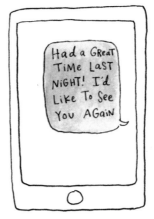

A MAN'S MOST
ATTRACTIVE ACCESSORIES

GUITAR:
SENSITIVE + GOOD
WITH HIS HANDS

FESTIVAL 2018

FRAMED ART:
EVIDENCE OF
ADULTHOOD

A VASE:
ANTICIPATES
BEAUTY

JOURNAL:
SELF-AWARE

RUNNING SHOES:
GOOD CALVES,
PROBABLY

WOK:
NOODLES ARE
IN YOUR
FUTURE

DaTiNG ConCeRNS

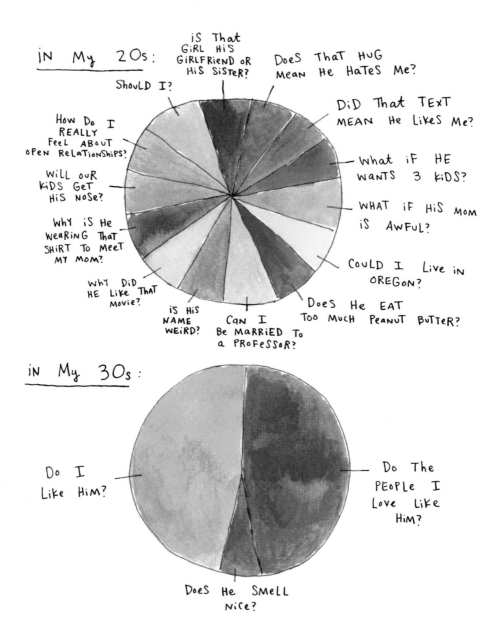

IN MY 20s:

iS ThaT GiRL HiS GiRLFRieND oR HiS SiSTeR?

DoeS ThaT HuG MeaN He HaTeS Me?

ShouLD I?

DiD ThaT TEXT MEAN He LiKeS Me?

How Do I REALLY FeeL ABouT OPeN ReLaTioNShiPS?

What iF HE WaNTS 3 KiDS?

WiLL ouR KiDS GeT HiS NoSe?

WHAT iF HiS MoM iS AwFuL?

WhY iS He WeaRiNG ThaT SHiRT To MeeT MY MoM?

CouLD I Live iN OREGoN?

WhY DiD HE LiKe ThaT Movie?

iS HiS NAME WeiRD?

CaN I Be MaRRieD To a PRoFeSSoR?

DoeS He EAT Too MuCH PeaNuT BuTTeR?

IN MY 30s:

Do I Like HiM?

Do The PEoPLe I Love Like HiM?

DoeS He SMeLL NiCe?

SIGNS OF
UNAVAILABILITY
AND WHY IT'S SO ATTRACTIVE

LIVES IN
A
DIFFERENT
CITY

PINING
IS
ROMANTIC

IN LOVE
WITH
SOMEONE ELSE

ALWAYS
DRESSES
WELL

EMOTIONALLY
STUNTED

FULL OF
SURPRISES

NON-
MONOGAMOUS

YOU'LL BE THE
ONE TO CHANGE
HIM

HAS
A
G.F.

KNOWS
HOW TO
LOVE

The DaTinG JunGle

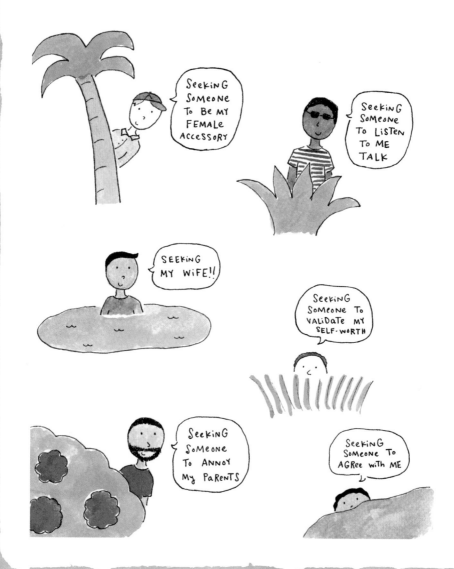

BOYFRIENDS aS
≥ CiTiES ≥

NEW YORK:
PROMiSES a LoT,
OFFERS VeRy LiTTLe

PARiS:
You NeveR QuiTe
FeeL GooD eNouGH

St. PeTeRSBuRG:
MoRe oF a
SUMMER FLiNG

Rio de JaNeiRo:
GoRGeouS, BuT NoT
veRy RESPoNSiBLe

FLoRENCe:
ARTiSTiC + SweeT,
PeRHaPS Too APPReciaTive
oF BeauTiFuL WoMEN

SANTA FE:
SPiRiTuaL + iNTeReSTiNG,
NoT a whoLe LoT oF FuN

PRAGUE:
VERY AWaRe oF
HoW BEAuTiFuL aND
iNTELLiGeNT He iS

SEATTLE:
CooL, BuT CoLD

San FRANCiSco:
SeemS ReaLLy CHiLL,
BuT acTuaLLy HiGH-
MAiNTeNaNCe

ANATOMY OF
The Guy To Avoid

GETS HAIR TRIM ONCE EVERY 2 WEEKS

GIVES A LOT OF EVIDENCE THAT HE'S DATING OTHER GIRLS, INCLUDING THE OFT-USED PHRASE, "WERE YOU THE ONE WHO..."

SAYS "I'M NOT LOOKING FOR ANYTHING" BUT THEN TAKES YOU TO A BISTRO WITH TWINKLE LIGHTS

ACCESSORIZES WAY BETTER THAN YOU DO

FOLLOWS A LOT OF MODELS ON INSTAGRAM

WOOS YOU WITH HIS CHIC APARTMENT AND INTOXICATING COLOGNE. CRUSHES YOU WITH HIS ONE-WORD TEXTS AND HIS DISINTEREST IN LEARNING YOUR LAST NAME

BOXERS WAY NICER THAN YOUR LINGERIE

SEEMS VERY AWARE OF HOW YOUR APPEARANCE AFFECTS HIS AESTHETIC

COMMITTED TO STYLE OVER PRACTICALITY, ESPECIALLY IN WINTER

I'M NOT LOOKING FOR ANYTHING RIGHT NOW.*

* I AM LOOKING FOR SOMETHING, BUT IT'S NOT YOU.

* I'M DATING SOMEONE ELSE I LIKE BETTER.

* I'M NOT LOOKING FOR ANYTHING RIGHT NOW, BUT IF YOU WERE HOTTER YOU'D BE AN EXCEPTION.

* I'M JUST USING THIS DATING APP FOR ONE WEEK WHILE I'M IN TOWN.

* I BROKE UP WITH MY GIRLFRIEND LAST NIGHT.

ASKING FOR LOVE ADVICE FROM FRIENDS

The KEY iS To DaTe A MAN FROM CanaDa.

DaTiNG A Canadian

WHY NOT Go FOR a MuSician?

DaTiNG A MuSician

STOP DaTiNG SuCH COMPLEX MEN!

MaRRieD To a BORiNG GuY

DONT YOU WANT WHAT I Have?

MOM

FIRST - DATE REPORT CARD

Name:	Date:	Location:
Jose	Feb. 28	Cute hipster bar

OUTFiT: B+
 Comments: Appeared to have put in
 effort, but footwear totally incorrect.

ORDERiNG: A
 Comments: Ordered a Negroni (a man
 after my own liver). Answered "sparkling"
 to the question, "Sparkling or still?"

CONVERSATiON: C
 Comments: Forgot to ask me questions.

BODY LANGuAGe: A+
 Comments: Great eye contact. Knee touched
 mine while sitting at the bar.

CHECK: D
 Comments: Split. Can he not intuit
 how much I spent on my nails + brows?

POST-DATE: A
 Comments: Drove me home. Put hand on my
 headrest as he was backing up.

HOW I KNOW
I'M FALLING IN LOVE

I always PUT ON LiPSTiCK
WHEN I eNTeR HiS NEiGHBORHOOD,
JUST iN CaSe.

I'M TeXTiNG
HiM AFTeR ONE
SiP OF WiNE.

EVeRY SoNG
ReMiNDS Me
OF HiM.

I wRiTe DowN
CONVeRSaTiON
TOPiCS I THiNK
WiLL iMPReSS HiM.

I PoST
oN SociAL
Media WiTH
HiM iN
MiND.

I PUT iN
a LoT oF
EFFoRT TO
MaKe HiS
RooMMaTe LiKe
ME.

MY FRieNDS
ALL KNOW
HiS MiDDLe
NaMe, FaVoRiTe
VeGeTaBLe, AND WaY
He LiKeS HiS EGGS.

RoM-COMS
FeeL
ReLeVaNT.

I'M 112 weeKS
DeeP iNTo HiS
SiSTeR'S iNSTaGRaM.

I WaNT TO
BuY HiM THiNGS.

FaLLiNG iN LoVE

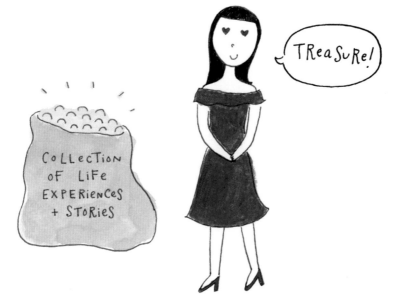

COLLECTION
oF LiFe
EXPERiENCeS
+ STORiES

TReaSuRe!

CHaPTeR 5
HeaRTBReak and LoSS

LiFe in 3 AcTS

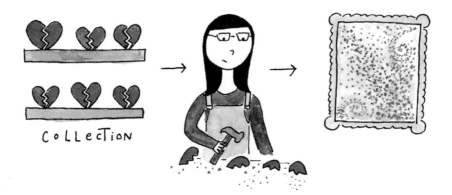

COLLECTION

BReakuP ExChanGe

 SELF - DOUBT,
DISTRUST OF ALL MEN,
DaMaGed CoNFidence,
PaiNFuL MEMORieS ON
EVERY STReeT oF THiS CiTY

LiFe LeSSoNS,
A BLueRiNT FoR
The NexT ReLaTioNShiP,
A New LeaSe oN LiFe,
WoNdeRFuL SToRieS To TeLL

ANaTOMy OF
HEARTBReaK

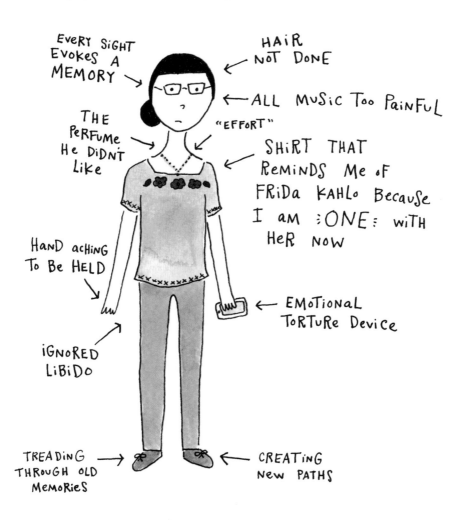

EVERY SiGHT EVOKES A MEMORY →

HAIR NOT DONE ←

THE PERFUME He DiDN'T Like →

"EFFORT"

← ALL MUSiC Too PaiNFuL

SHiRT THAT REMiNDS Me oF FRiDa KAHLo BecaUse I aM :ONE: wiTH HeR NOW

HAND achiNG To Be HELD ↓

EMoTioNaL ← ToRTuRe DeviCe

iGNoRED LiBiDO ↗

TREADiNG → THROUGH OLD MeMoRieS

← CREATiNG New PATHS

HiM AS MY
BOYFRIEND

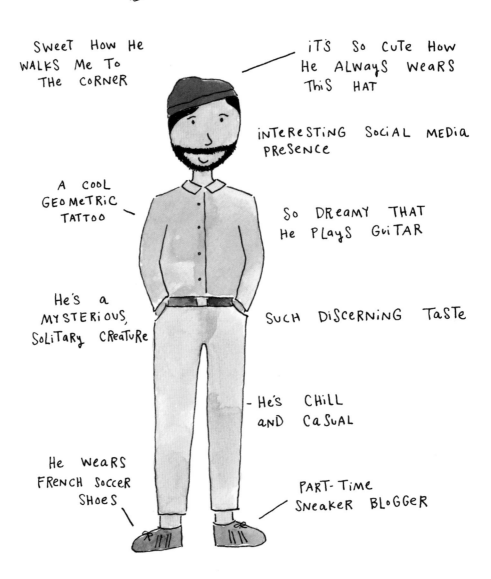

SWEET HoW He
WALKS Me To
THE CoRNeR

iTS So CuTE HoW
He ALWayS WeaRS
ThiS HAT

iNTeReSTiNG SoCiAL MeDiA
PReSeNCe

A CooL
GEoMeTRiC
TATToo

So DReamy THAT
He PLayS GuiTAR

He's a
MySTERiOUS,
SoLiTaRy CReaTuRe

SUCH DiSCERNiNG TaSTe

- He's CHiLL
aND CaSuAL

He WeaRS
FReNCH SoCCeR
SHoeS

PART-TiMe
SNeakeR BLoGGeR

HiM AS MY EX

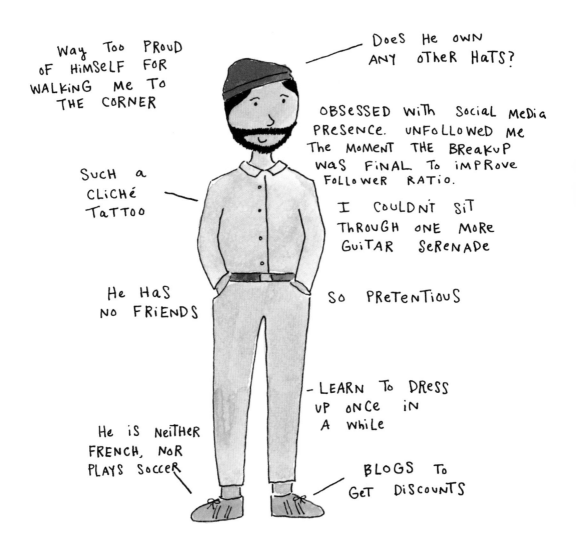

Way Too PROUD OF HiMSELF FOR WALKiNG Me To THE CORNER

DoeS He OWN ANY oTheR HaTS?

OBSeSSED WiTh SociaL MeDia PRESeNCE. uNFoLLoWeD Me The MoMeNT THE BReaKuP WAS FiNaL To imPRove FoLLoWeR RATiO.

SucH a CLiCHÉ TaTToo

I COULDNT SiT ThRouGH oNE MoRE GuiTAR SeReNADe

He HaS No FRiENDS

So PReTeNTiouS

He iS NeiTHeR FRENCH, NoR PLAYS SocceR

- LEARN To DReSS uP oNCe iN A WhiLe

BLoGS To GeT DiSCouNTS

SoMeThiNG ShiNy

When I was five, my parents took me to Mexico on a last-ditch-effort family vacation before they got divorced. I remember magenta embroidery, giant lizards (perfect for photo ops even before Instagram), dolls in sombreros, and having to order Coke without ice. I remember digging my feet into bathwater-warm sand on the edge of the beach, watching the aqua foam hide and then expose my toes with every rhythmic wave. I zigzagged in and out of the water, looking for pebbles and shells.

———————

Halfway buried in a blond dome of dry sand a few feet away, I saw something shiny. It was gold, for sure. I thought I had discovered Mayan treasure. Within seconds, I could already imagine the TV interviews and the mansion we'd move into. I picked up the glistening coin and held on to it for a while, knowing my life was about to change.

I ran over to my parents, who were talking to some local guys, and showed them the loot from my archaeological dig. "*Gold,*" I announced, like an old-timey Alaskan pioneer.

"Oh, good," my dad said. "Now I have enough change so I can do that." He pointed to a paraglider.

Two Things Dawned on Me:
1. My Treasure was only Worth a Few Cents
2. My Dad was About To Die on a Paraglider.

I immediately threw a tantrum. First of all, my dreams were crushed, but even worse, I couldn't stand the idea of my dad going into the sky. When you're five, your parents are your entire world; I couldn't bear to see my world fly up into clouds, my dad just a wisp of a shadow up in the air, sure to crash before my eyes into the Gulf.

My parents tried to reason with me: "It's safe, Mari. Look, see, that man is doing it. Dad is going to be in a harness, he'll be completely secure. Please, Mari, stop screaming."

But I knew. I knew what he didn't know: that I was saving his life, and that he'd thank me someday. After an extended episode of sobbing, my dad conceded, "Okay." He sighed and looked at the guys who had stood by and witnessed my entire meltdown. "Thanks anyway."

I always loved my dad dearly. But our relationship became strained when I was in my early twenties for no reason clear to either of us, so I looked for evidence in my past. I must have done something hurtful but I couldn't think of anything specific. I wondered if there was anything to apologize to him for, and decided I would apologize for not letting him go paragliding in Mexico.

My dad had a heart attack when I was twenty-eight. I was still living in Washington, D.C., but he was in San Francisco, so I'd been getting medical updates by email every couple of days after his quadruple-bypass surgery. It's very stressful to hear about someone's frequently changing condition that way, the ups and downs, the frantic phrases, the forced humor, the questions.

As his post-surgery condition consistently worsened, I decided to fly out to see him in the hospital. It was time to make good on that apology. In the days leading up to the visit, I nervously walked around my neighborhood at night while mentally rehearsing my speech over and over: *I'm sorry I didn't let you go paragliding. I'm sorry for everything else. I forgive you, and I hope you forgive me.*

He died the morning before my flight.

When you see someone in a cast, you know to give up your seat and perhaps even open a door for them. Shouldn't people going through mental or emotional health upsets have their own version of a cast, so that others know to take care? There have been many moments since my father's death during which I wished modern mourners could be identified by something. How about one of those slinky black lace head coverings that looks like it could take you straight from mass to a tango bar in 1940s Buenos Aires? I'd affix it to my hair every morning so it could tell the world, "This girl is going through something here. Treat her with a bit of extra gentleness."

The day of my father's death, "mourner" became my identity. It manifested itself in a variety of surprising and life-changing ways. I began drawing a daily illustration. I wrote more than I ever had before, and stopped fearing submitting my writing for publication. I signed up for guitar lessons, salsa lessons, surf lessons, design lessons. I made many new friends, and peacefully distanced myself from relationships that should have ended long before. Completely out of character, I actually finished books and made progress on my language app and put the final touches on my apartment décor. I amped up my exercise. I can do the splits in a forearm stand, which I'm positive would have ended in an ambulance ride in years past.

If asked, "How did you get the motivation to do all that?," I answer, "Oh, easy: just have a parent die." Eek. But it's true.

Knowing I'm not immortal now—that no one is—every morning I get a rush of adrenaline at the sheer thought that I am alive. This feeling is as wonderful and terrifying as it sounds. I am fully aware that my world could end tomorrow, which leaves me invigorated, but also more anxious. I am living intensely and quickly and productively and richly, but on the flip side, the sudden realization of mortality kept me up at night throughout my grieving process. When, after David Bowie died, many of my friends shared their nascent awareness of mortality, I observed their revelation like they were a bunch of teenagers getting drunk on their first Bacardi while I sat back and sipped straight whiskey.

The ways we use the word *habit* in English are related; it originally meant dress, attire, and later came to denote an acquired behavior pattern. We still refer to a nun's costume as a habit. Etymologically, a habit is *what one has*. Mourners may not wear fancy head coverings when someone dies anymore,

but we carry our own markings around on public transportation, at work, at our desks at home. I am in mourning when I overreact to harsh words. I am in mourning when I learn a new song on the guitar. Mourning has become so hopelessly intertwined with my daily activities that I can't separate one from the other. Mortality awareness, increased sensitivity, nighttime anxiety, and a desperate need to create and produce: these are what I have.

The morning of my father's death, I put on my mom's locket—an exquisitely engraved round art deco thing—which she had recently given me. I remember her buying it because she rarely bought anything for herself, and she kept a picture of me inside. I always loved it because she's wearing it in all my favorite photos of her.

With my hair pulled back and my cheeks pink, I walked to the office like I did every other day. People asked me why I came to work that day, but I really didn't know what else to do. If the black velvet I wore felt like a signal of my invisible wound, the locket was my armor to face the day. With it, I channeled my mother's strength and sophistication. I was basically the Jackie Kennedy model of mourning.

When I got to my office, I unwrapped my twice-raveled red scarf and draped it over my chair. The gold chain of my mom's precious locket slipped out and fell to the floor. I gasped, and grasped my neck. "No. No no no no," I said, maybe to the planets or God or the universe. I tore up my office, searching behind books and under lamps and even in drawers. Nothing.

I moaned over the loss of the locket. I hunched over my desk and sobbed for a solid ten minutes. I held the chain up to my cheek and ran it against my skin, trying to remember the strength I'd been able to channel just an hour earlier. I called the coffee shop I'd stopped at, the front desk of my office, clinging on to a shred of hope that someone had spotted it. Nothing.

The next morning, I walked my exact same route, but this time with my eyes on the sidewalk. I looked in piles of leaves, in sidewalk cracks, in gutters. I left notes with my email address along my path. When I was almost at my office, I saw something shiny. It was round and it caught the light of the sun and the streetlight, just like my mom's locket. I felt tears of gratitude welling up, with renewed hope that everything would be okay. I quickened my pace and walked toward the shimmer.

It was just a coin.

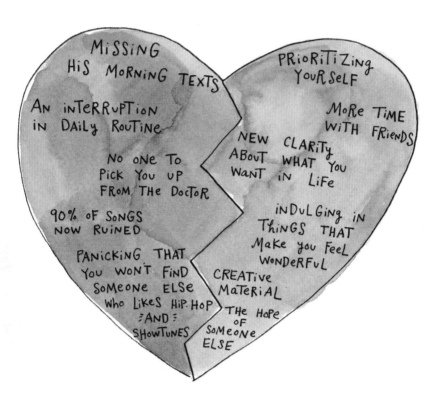

PRESCRiPTioNS FoR a
BROKEN HEART

Rx EYES

TAKE THEM
To BEAUTY:
A MuSEUM, A Movie,
A FLoWeR FiELD

Rx BoDY

MAKe iT FeeL
NiCE:
Give iT A BATH,
A MASSAGe, A
NuTRiTiouS MEAL

Rx HANDS

CREATE
SomeTHiNG WiTH
THEM: A PoEM,
A PiCTuRe, A PAN
oF MuFFiNS

Rx FEET

PuT THEM oN
a DANCE FLooR, A
YoGa MAT, A RunniNG
TRAiL, A NEW
PATH

Rx BRAiN

Give iT a NAP
FRom THE
inTeRneT
aND PRoViDe
iT WiTH a
GooD BooK

Rx SPiRiT

LiFT iT uP
By TALKiNG To
FRieNDS, TRYiNG A
New HoBBY, aND
GIVING YouRSeLF
SomeTHiNG To
Look FoRWARD To

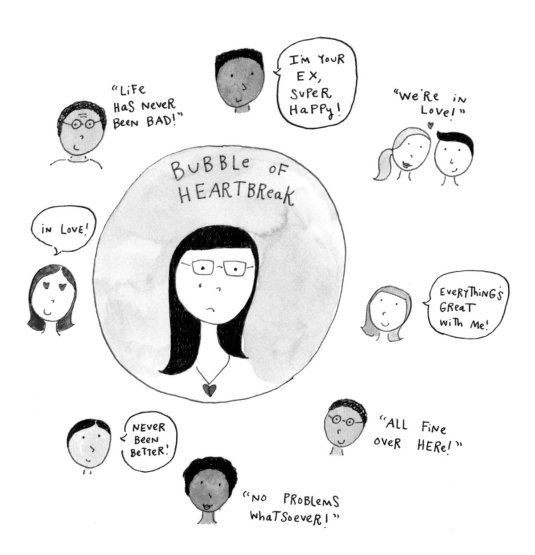

SYMPaTHY

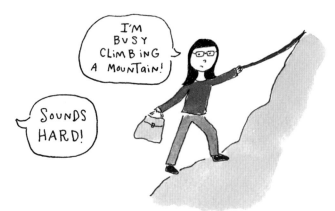

EMPaTHY

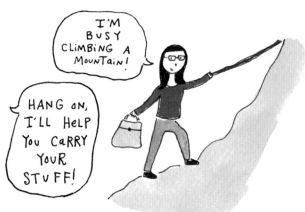

WHaT To SaY

"I caN'T iMaGiNe, aND I'M
 So SoRRY."

" I'M BRiNGiNg You LaSaGNa
ToNiGHT. IF You DoN'T FeeL Like
TalkiNG, I'LL Leave iT aT YouR
 DooR. "

" I'M THiNKiNG ABouT You. " (oN REPEAT)

" You'Re PRoBaBLy NoT, BuT LeT'S BuY
a PReGNaNCy TeST JuST iN CaSe.
You'Re NoT ALoNe. "

" TELL ME MORE. "

" I THiNK YouR HaiRCuT LookS GREAT,
BuT iT wiLL GRow Back BeFoRe
 You KNow iT. "

MANY MOMENTS OF MY GROWING UP HAPPENED OVER COFFEE.

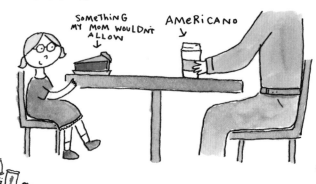

SOMETHING MY MOM WOULDN'T ALLOW ↓

AMERICANO ↓

AGES 0-18:
GOING TO COFFEE SHOPS WITH MY DAD. WE WOULD CHITCHAT ABOUT LIFE, OR I'D WATCH HIM DRAW OR READ THE NEWSPAPER.

AGE 19:

← I STARTED WITH 4 SUGAR PACKETS AND WORKED MY WAY DOWN TO O.

I LEARNED TO ENJOY COFFEE ON MY STUDY ABROAD ADVENTURE IN ITALY. ORDERING A DOUBLE ESPRESSO MADE ME FEEL SO GROWN UP. →

A DOPPIO, PLEASE!

I AM SO CHIC.

I GUESS THIS IS IT.

I GUESS THIS PLACE IS RUINED NOW.

AGE 21:

MY FIRST BREAKUP HAPPENED ON THE OUTDOOR PATIO OF A COFFEE SHOP I LOVED.

AGES 22-30

← A FOAM HEART IS A GOOD OMEN

SO MANY "SAFE" FIRST DATES AT COFFEE SHOPS.

AGES 28+
I DRINK AN AMERICANO ON MY FATHER'S BIRTHDAY.

DAD

My EXeS AS COFFee

DiNeR CoFFee
at 2AM:

CHeaP + LukeWARM,
GoT THe JoB DoNe

HeMP LaTTe:
A BiT WeiRD
+ FRaGRaNT
BuT BecaMe aN
oBSeSSioN

SoY LaTTe:
ReLiaBLe,
BuT oNLY ReaLLy
ReLeVaNT iN
2008

ALMoND MiLK
LaTTe:

CHiC, BuT VeRY
AWARe oF
HiMSeLF

CAPPuCCiNo:
iNDuLGeNT,
iNTeRNaTioNaL
RoMaNCe

CaFé CoN LeCHe:
The oNe I
FoRGeT aBouT,
BuT exacTLy What
I WaNT + NEED

The ONe ThaT I WaNT

When my dad died, I didn't know where he went. Literally,
I didn't know the location of his body. He had expressed a desire
for an environmentally friendly burial, which involved a
biodegradable casket and a certificate with some GPS coordinates
to mark where he was buried in lieu of a tombstone. I didn't know
where exactly he was buried, but knew someday I'd seek out
that information, and spend some time wandering around a field
looking for coordinates that point to his bones.

In the meantime, I tried to bring him back to life by looking for
love to rescue me from grief. Well, not so much "looking for love"
so much as grasping at any sign of romance I could possibly find.
For a while, this meant going on as many dates as I could fit
in a week. It was easier, in a way, to talk to someone I'd never met
than to talk to a close friend. It felt like trying on a new life for a couple

of hours, one I could wear until my real one started poking through the seams. They all began the same way: black eyeliner, blue suede pumps, two spots at the bar. About an hour in, I would inevitably blurt something to the effect of, "I'm sorry, my dad died, I should go." I think I've singlehandedly scared half a dozen men off Tinder forever.

By compulsively going on dates, I was trying to skip the stages of grief and find a solution for the constant ache of loneliness in my sternum. I thought I'd be "fine" within a month, but instead, the stages just kept cycling in a different order.

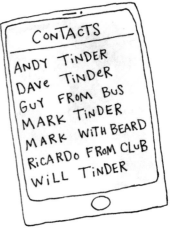

"This too shall pass." That's something a lot of people told me when my dad died. All these young people, who had maybe lost a pet dog, an elderly grandparent, a job, apparently held the universal Wisdom of the Ages: my grief was going to pass. People want to believe that grief, like stubbing your toe, follows a crisp, orderly pattern, and that one day it's done and nobody wants to talk about it or has to hear about it ever again.

But the truth of grief involves stepping into the deepest, darkest, monster-infested zone and acknowledging, "This place is the absolute pits, and you might be here a long time." It takes a very brave person to step into the lightless murk of true empathy, and I'm fortunate to have a few of these brave souls in my life.

But dating someone new was not the solution I needed it to be, so I looked to my romantic past. Through expressive emails and dramatic text message proclamations, I tried to bring old romances back to life. One of them would surely work out. One of them would complete my story, and I would no longer be alone. In fact, my story would end with romantic triumph!

"This too shall pass." It hurt the most when Digo said it because I wanted empathy from him more than I wanted it from anyone else. "Friend" would be an appropriate term for his relation to me, and "pen pal" would also do, but "fantasy" is the most accurate. We didn't see each other often, so I could make him whatever I wanted him to be; in this case, I had imagined Digo as salvation from my isolation.

The night my dad's death really hit me, I called Digo. I was desperate to get out of the monster-infested zone and needed him to save me. I needed him and only him to come into the dark, terrible place of true empathy for me, with the

intention that we could come out together, holding hands, walking down a street in the East Village. I was desperate for Digo like I was desperate for my dad.

I cried to Digo and I told him how angry I was, angry for experiencing heartbreak and loss at the same time, and angry at the earth for taking my dad down below that field in California, with only GPS coordinates pointing to his bones.

"This too shall pass," he said.

A couple of weeks before my father died, I went to New York with my then-boyfriend Alejandro. I don't love traveling with other people, but I made the exception for him, and he whispered in my ear how much he appreciated it while we were listening to Louis Armstrong singing "La Vie en Rose."

We held mittened hands down Fifth Avenue as I confessed to him that my dad was on my mind, remembering all the incredible things he had introduced me to, like New York City, Thai food, and Sam Cooke records. So Alejandro and I danced to Sam Cooke's "Having a Party" in a dimly lit Upper West Side living room. I remembered doing the same with my dad in our brightly lit Seattle living room two decades earlier.

Before Alejandro, I had only experienced the romance of New York with Digo, when we met up at a speakeasy and spent the next day walking arm in arm around Central Park. For me, New York was so dreamlike that it glossed over the realities of both of these relationships. When I was with Digo in New York, it felt like we had known each other forever, even though we'd seen each other only a handful of times. When I was with Alejandro in New York, it felt like we were the only two people who existed.

The train ride home to Washington, D.C., washed away the gloss of New York. Actually, Alejandro and I broke up right there on the train when I found out the person he had been texting all weekend was not, in fact, his brother.

I couldn't separate the feeling of heartbreak from the feeling of grief, because both felt like rejection. The two most significant men in my life had left me at the same time.

STAGES oF GRiEF

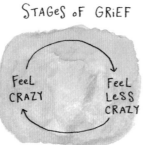

Feel CRAZY — Feel LeSS CRAZY

After "This too shall pass," Digo became the last to leave me in a series of men I used to try and resurrect my dad. Here's a dating tip from me to you: guys don't really have an interest in taking the place of your dead dad.

There wasn't a certain day that friends stopped cautiously asking me how I was doing; the conversations just changed as I slipped back into a social life and stopped looking like I was on hallucinogens. I no longer had nightmares and I laughed a lot more. I put some din-

GRiEF

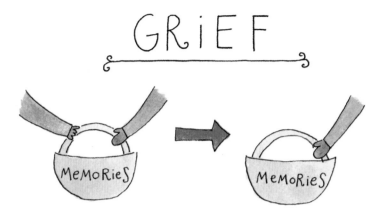

ner dates with *friends* on the calendar. The weight of a concrete slab had been lifted. I figured I was in the final stage of grief.

The final stage of grief is acceptance. That's a nice word. It sounds like a Zen-like state of openness and newfound peace.

But now I understand that acceptance is actually a heartbreaking realization. My father is dead and nothing can bring him back. Not an old boyfriend, not a new boyfriend. Acceptance is not a relief; it's the realization that you will always carry grief with you.

The evening I lost Digo's friendship was the evening I moved into the final stage of grief. Months of silence followed after I cried to him on the phone, without an offer to sweep me away and tour Central Park in a carriage for the rest of our lives—or even a sympathy card. I was waiting for him to take up the responsibility of my consolation prize, and he silently declined.

I marked the final stage of grief by calling Digo with an update: "It never passed," I snapped at him. "You told me it would, but it didn't, and it never will." I was mad at him for not having the empathy that I needed, and mad that he could not be the magic potion my heart needed to heal. But more than that, I was mad that no man could be that for me.

The moment I hung up on Digo, I said good-bye to my dad for good. There was no bringing him back—not physically, not in the ambiguous spiritual realm, not through love from other men. I'd have to go through this pain alone, and it was up to me to decide if it would make me weaker or stronger.

The LiFe I WiLL NoT Live NOW That We BRoke UP

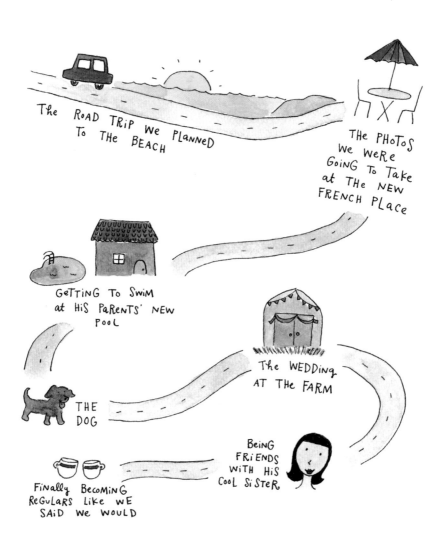

The ROAD TRiP We PlanneD To THE BEACH

THE PHoTos We WeRe GoinG To Take at THe NEW FRENCH PLace

GeTTiNG To Swim at HiS PaReNTS' NEW PooL

THE WEDDing AT THE FARM

THE DOG

BeinG FRiENDS WiTH HiS CooL SiSTeR

FiNally BecomiNG ReGuLaRs Like WE SAiD We WoULD

BReakuP RiTUALS

LiGHT a CANDLe
FoR The LiFe
That wiLL NoT Be
(ViSiTinG HiS ReLaTiveS
iN SWeDen NexT SuMMeR)

GeT a DRaMaTic
HAiRCuT

(oR A TeeNY TRiM
THAT FeelS Like
DRaMa)

ENGRAVe a
Piece oF JeweLRY
He Gave You
WiTH a NEW
MESSAGe

DeLeTe THE
PHoToS That
Make You CRY

Buy YouRSeLF
A BeauTiFuL Thing

LET
LOOSE

Chapter 6

Overcoming Disappointment

YOUR LiFe

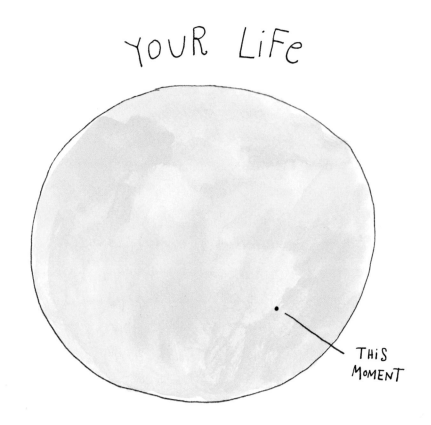

THiS
MOMENT

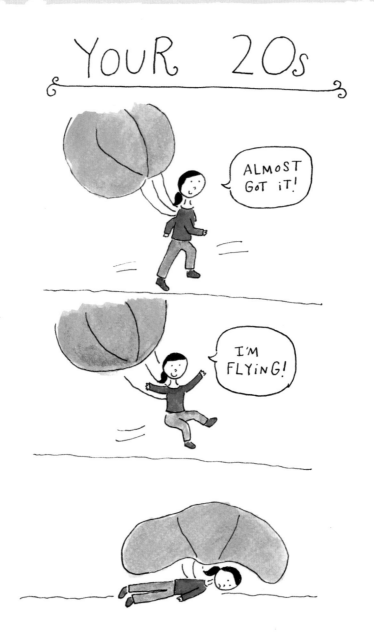

ReSiLieNCe

 ReSiLieNCe BeGiNS When You've BeeN KNocKed ARouNd.

You CAN EiTHeR SAY:

OR You CaN TAKe a MiNuTe To REGRoup AND SAY:

 PHEW. NeveR DoiNG ThaT AGaiN.

 LeTs TRY ThaT AGaiN Now ThaT I KNow MYSeLF BeTTeR.

STRUGGLiNG ThRough ReJecTioN, HeaRTacHe, oR LoSS iS iNeviTaBLe. ReSiLieNce iS ABouT The cHoiceS You Make AFTeRwARD.

 LeaRNiNG MoRE ABouT YouRSeLF

 PRoAcTiveLY FiNDiNG ThiNGS To Be GRaTeFuL FoR

 DRawiNG YouR OwN SiLveR LiNiNG

ONCe You've DeveLoPeD ReSiLieNce, You'LL Be AMaZeD AT YouR STReNGTH!

· 115 ·

SPRING

"When is spring going to get here?" is something I hear every April
in Washington, D.C., when we have yet to experience a complete
week of flawless blue skies and pure sunshine and scampering baby
bunnies. Instead, it's usually rainy and chilly for a couple of months,
with a few preciously tender days here and there. It's damp patches
of grass, cars that spray you when they drive through puddles,
earthworms, lingering patches of snow, and T-shirts cloaked in
oversized scarves. Spring is fussy and unpredictable, a pimpled
teenager ready to snap at any moment, who occasionally shows
hints of becoming an elegant young woman.

Spring is the promise of a solution to a problem (the problem being winter,
which, if you've spent any time in the Midwest, you know to be the cause of
mental anguish and despair), which is why it's so frustrating when it doesn't
deliver. I believe we all kind of secretly expect that on March 21 of each year
the cold clouds will part like silver drapes, unveiling a Renaissance painting in-
terpretation of our cities. It's not what we were promised, nor what we've even

CoRN CoB
(with MaYoNNaiSe)

SeaFood ToSTada
(wiTH MAYoNNaiSe)

ToRTa
(wiTh
Mayonnaise)

TACo
(with MayoNNaiSe)

probably experienced, and yet we feel entitled to it. It is embarrassingly infuriating when we are forced to continue slogging through with no expiration date. Living with an unsolved problem makes us squirmy.

I expected Mexico City to be my spring. Not my earthworm-damp-puddle spring, but my Renaissance-painting spring. I felt entitled to it.

Some moments were inspiring. But I didn't get the life revelations I expected. Specifically, I had been expecting to have a spiritual experience at Frida Kahlo's Casa Azul. Frida Kahlo is, of course, the patron saint for every young woman who believes herself to be a heartbroken artist. I imagined myself walking through her house, touching the holy linens of her bed and the sacred ceramics of her kitchen. I'd trail through the gardens, sitting to ponder the lessons of heartache and the beauty of completion.

As I made my way to Casa Azul underneath the buzzing metropolis above, I tried to identify with the route of the metro line. It would take me from the solemn neighborhood where I was staying, through the hullaballoo of the downtown commercial district, underneath blooming parks and ancient monuments, past the chaotic highways lined with gas stations and junkyards, to the end of the line, where I'd emerge into a festive barrio promising divine revelation. I had the hubris to think that this underground journey could mimic my recent life journey: my past year had twisted through chaos and silence, the residue of eruptions and the overgrowth of memories, until I was sure to arrive clean and ready in a new place.

This was not the way of the metro. After an uncomfortable but direct train ride, the escalator lifted me onto a gum-caked sidewalk surrounded by car dealerships. No sign of candy-colored flags overhead, just a mess of telephone wires. No turquoise houses embraced with bougainvillea, just a crowded Starbucks and a lonely mall. No smells of homemade tortillas wafting through the air, just morning smog. I took out my dog-eared guidebook and tried to make sense of the map to Casa Azul.

PLaceS I GoT LoST TRYiNG To FiNd iN MEXiCo CiTy

FRida's HoUSE

ChuRRo CaFé

MoDERN ART MuSeuM

A MaRGaRiTA BAR

ThiS MeTRo STaTioN

I finally decided to hail a taxi that took me on a labyrinthine ten-minute drive to Frida's front door. A line of tourists snaked around the blue house. I joined them, sweaty and flustered from my failed attempts at whimsy. I therefore arrived at the house feeling entitled to whimsy.

The magic that I had demanded from this experience—the enchantment of the gardens, the emotional potency of her wheelchair, the power of the linens—fizzled as more and more tourists crammed into each room. I had planned to get there right when it opened to have the house all to myself, but getting lost delayed my arrival time to coincide with the height of the late-morning foreigner frenzy.

I was pushed through the house by the crowd and then spat out into the gardens. Ah, the gardens: This was where I had presumed I would return to wholeness and find my own personal spring. I took an unclaimed seat on a bench underneath a lemon tree and I waited. All I could think about was my residual annoyance over getting so lost, and how uncomfortable my shoes were. The discomfort of my shoes led me to the discomfort of my life.

I had just gone through the trials of seeking a career, the pain of failed relationships, and the profound grief of losing a parent. What was going to make that all worth it? A worrisome thought slipped into my inner monologue: What if

there was no point? What if I was just an ordinary person who got a dose of bad luck in a certain period in my life? What if it there was no universe-orchestrated happy ending, but just a continuation of some bad days and some good days? What if there were just seasons, and no eternal spring?

I had secretly been waiting for my cosmic reward ever since my dad died. I had a hunch every time I went on a date, every time I applied for a job, every time I sent an essay to a magazine, that this thing would be my grand finale and I would see that life had a treasure trove in store for me, if only I could pass a certain number of tests. I didn't articulate this thought, but I believed it was inevitable. The cosmos had received the large sum I deposited the year before, and this was the year I'd get a hefty return. With interest.

I wandered around Frida's garden for a while, watching the waves of tourists swell and break. I watched stray cats sniff the flowers and a man sip coffee at the café decorated with dancing skeletons while I waited for an answer. In the meantime, I wondered, *What was the point of coming here?* I wasn't sure whether I meant Casa Azul, Mexico City, or this place in life.

People are so uncomfortable with the lack of a point to life that almost every religion has a belief in a higher plan for each person's existence. Even people who eschew religion may instead put their faith in astrology or the universe, attempting to make sense of rejection as something that "wasn't meant to be," and something that paves the way for "something better to take its place." It's a comforting thought until you get tied up in the logic that the universe's plan has failed plenty of people.

The morning drizzle turned into midday rain, and I ducked into the café to wait out the deluge. I wasn't going to find answers in Frida's linens, that was for sure. I cooled off and enjoyed my espresso much more than I enjoyed anything inside the crowded house or in the gardens. I drew in my sketchbook for an hour and watched as the sun finally swallowed up the rain. The flowers looked like they'd gone through a carwash, but the greenery triumphed and looked all the more beautiful for it. I thought about returning to the house and trying to have a moment with the wheelchair, but the break had made me hungry. Today was not a day for answers, but it was certainly a day for tacos.

I gathered my notebook and my purse, wished the barista *buen día*, and headed back through the house onto the sidewalk. I looked down the street and saw overhead a series of candy-colored flags, flapping in the springlike afternoon breeze. Tired of trying to find logic in an illogical city, I put away my map and followed the flags instead.

MEXICO CITY, MEXICO

FOUND FLAN
WHILE LOOKING
FOR DINNER

FOUND THIS
ASYMMETRICAL
BACKPACK WHILE
LOOKING
FOR A
VINTAGE
DRESS

FOUND AN
AÇAI BOWL
OF DREAMS
WHILE LOOKING
FOR MY APARTMENT

FOUND a FOREST
WHILE LOOKING
FOR a CASTLE

FOUND A
ROOFTOP MARGARITA
WHILE LOOKING
FOR MY AÇAI BOWL

FOUND a
COURTYARD
FULL OF
WELL-DRESSED
SKELETONS
WHILE LOOKING
FOR LUNCH

FOUND
A NEW
FRIEND WHILE
LOOKING FOR
HUEVOS RANCHEROS

FOUND a BACHATA
CLUB WHILE LOOKING
FOR A SALSA CLUB

FOUND a GIANT FLAG WHILE LOOKING FOR a GIANT CHURCH

FOUND a CHURRO EMPORIUM WHILE LOOKING FOR A TRADITIONAL DANCE SHOW at THIS FABULOUS THEATER

FOUND a CHRISTMAS-THEMED SHOPPING MALL WHILE LOOKING FOR FRIDA KAHLO'S HOUSE

FOUND a SECRET ALLEY WHILE LOOKING FOR THE SUBWAY

FOUND a GARAGE FULL OF HOMEMADE TORTILLAS WHILE LOOKING FOR THE FLOATING GARDENS OF XOCHIMILCO

EMOTIONAL HANGOVERS

GETTING REJECTED
FROM a JOB
YOU REALLY WANTED

SEEING AN
EX ON A
DATE

FIGHT WITH
a FRIEND

DINNER WITH
AN OLD LOVE

VISITING A
PLACE YOU ONCE
LIVED

FINISHING
AN INTENSE BOOK

DiSaPPoinTMenTS:
WHERe ARE THEY NOW?

THe univeRSiTy I DiDN'T GeT inTo:

I MiGHT Be A CooL PROFeSSoR MARRieD To a KeNNeDy OR A LaWyeR HaVinG A MiDLiFe CRiSiS.

The JoB I DiDN'T GeT aS a MeN'S STYLiST:

I MAy Have WoRKeD My way uP To BeCoMe oBAMa'S SuiT ConSuLTaNT oR I May Have QuiT AFTeR 2 weekS BeCauSe I oRDeReD The WRoNG SHade oF NAVY.

THe SuRFeR WHo BRoke My HeART AFTeR 5 DATeS:

We MiGHT Be SuRFinG ToGeTHeR in AuSTRaLia oR He MiGHT Have TuRNeD ouT To Be A MANSPLaineR.

THe WRiTinG WORKSHoP in THe MouNTainS THaT ReJecTeD ME: I MiGHT Have WRiTTeN THiS Book in The MouNTainS— inSTeAD I WRoTE iT in SPAiN.

The $1,000 MAGaZine ESSay CoNTeST I LoST: I'D Have $1,000.

ReJecTioNS

TYPE OF REJECTION	REJECTION METHOD	How iT FEELS	PRESCRIPTION
LoVe	YouR TexT Going UNaNSweReD	Like You ARe The PERSON EQUIVALENT oF A DiSCARDeD FLoweR iN The TRASH	꞉SiLeNTLY꞉ Thanking Them FoR ReLeaSiNG You To MeeT SomeoNe Who WiLL ADORE EVERY PART oF YOU
WoRK	A SCARY PHoNe CALL	WhaT You ThouGHT ABouT YouRSELF WaS WRoNG	KEEP WORKiNG (THAT'S How You WiN)
FRieNd SHiP	A SLoW SaD Fade	Like a LoSS oF LoVe	LeaRN ThaT You ARe NoT FoR EveryoNe aND THAT iS ꞉OKAY꞉
oPPoRTuNiTy ThaT WouLD Have BeeN AMAZiNG	A PoLiTE LeTTeR	The LoSS oF AN ALTeRNATE ReaLiTy	Make a New PLaN FoR THe Time You WouLD Have SPeNT oN That oPPoRTuNiTy. MAKe iT GooD.

REJECTION FEELS LIKE
THINKING THAT THE CREDITS
ARE ABOUT TO ROLL IN THE
MOVIE OF YOUR LIFE, AND
REALIZING IT'S NOT EVEN HALFWAY
OVER.

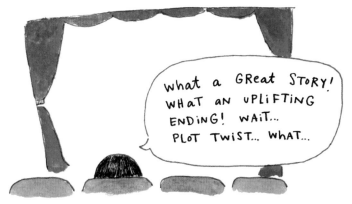

GRaNada

I pick a guiding word at the beginning of every new year—it's my version of a resolution that comes without the accompanying guilt and looming obligations. One year, my word was *thanksgiving*. My late twenties provided me with a series of growth opportunities, and I'd harvested that growth by drawing and writing them out. This year would be to enjoy the harvest. I planned to appreciate, to share, and to delight in the abundant season of my life I'd found at last.

Spain seemed like a nice place to do this. I'd spend a couple of months in Granada, a city I'd chosen after Googling "bohemian cities in Europe." After becoming an artist and acknowledging that I'd become an artist, I wanted to enjoy the *feeling* of being an artist, which for me meant hobnobbing with free spirits and sketching in charming cafés and cave bars. In Granada I was going to draw, and learn to paint murals, and be the person I have always wanted to be.

Before I left Washington, D.C., I bought myself a locket in the shape of a pomegranate that opens to reveal a ton of red gemstones inside that look like seeds. It was my special talisman for this trip, specific to this sweet season of my life. I didn't know then that the pomegranate is the symbol of Granada.

Granada *means* "pomegranate"! They were everywhere, including on the street lamps and manhole covers. Every time I got frustrated with the little inconveniences of being foreign, I quickly reverted back into my default of grateful. I was living out my dream in a setting that matched: the city was lined with cypresses, sprinkled with orange trees, built with ornate painted tiles, and, of course, decorated with pomegranates. My greatest responsibility every day was to walk along the river to flamenco class.

I'm thankful everything sweet is sweet because it is finite. I constantly rolled this Anthony Doerr quote around in my head while exploring my temporary home. I quickly became attached to Granada and began lamenting its impermanence. I wanted to stay there forever and I wanted to stay in that time of my life forever.

Then I collapsed in a hotel lobby in a small town where I'd gone to finish up a big project. My legs were oddly heavy and my hands were tingling. I couldn't get up, so I squeaked to another tourist that I needed to get to a hospital. Five tests and five hours later, I was on a seventy-five-minute ambulance ride back to Granada and in for the loneliest, scariest night of my life.

By that evening my legs and arms were paralyzed. I had been shoved into an emergency waiting room with thirty other people, no Wi-Fi, and no one to help me get a cup of water, help me go to the bathroom, or advocate for me in any way. I cried under the fluorescent lights for hours, unable even to wipe my own tears.

A few days prior, my foreignness had been a great source of material for illustrations and funny stories. But now it was the source of terrifying loneliness. I tried to ask a nurse to help me call my mom, and she just shrugged and walked away; my Spanish could get me through flirtations and flamenco class, but apparently fell short in medical speak. I was desperate for the relief of sleep, but feared missing my name being called. My temporary wheelchair was killing my back and I'd lost the ability to adjust my posture. Nurses kicked around my belongings, and I ached for all I had suddenly lost.

When I eventually got a scan late that night, it revealed extreme nerve damage caused by a mystery virus. (A couple of days later, we would learn it was Guillain-Barré syndrome, the cause of which is unknown.) The neurologist stoically told me that my paralysis wasn't permanent, but I'd be in the hospital for a few weeks. "A few weeks" sounded like such a short amount of time when I'd answer the question "How long are you in Granada?" It sounded like an eternity as an answer to "How long am I going to be in the hospital?" A

janitor wheeled me to a shared room where I couldn't bear to look outside at beautiful, glittering Granada. The fear of the unknown was bearable, but the disappointment of a journey cut short was harder to stomach.

After a few days of disorientation, I began focusing my energy on feeling sorry for myself. I wanted to be able to change sleeping positions without the help of two nurses. I wanted to be able to lift a spoon and put on Chapstick. I wanted to be able to get complex medical updates in English. I wanted to type an Instagram caption without feeling exhausted. I wanted to wiggle my feet. But most of all I wanted to be in the world, just doing world-things like buying a cappuccino and drinking it. Smelling an orange tree. Deciding which way I wanted to go, and then going.

I quickly learned that choice is a luxury, and is largely responsible for pleasure. Half the enjoyment of putting on perfume is the decision to do so, and the decisions of which one, where, and how much.

I never connected with the message of "You are not your body." I like being my body! I like getting dressed, drinking cocktails, eating churros, taking baths, stretching, kissing, and picking perfume. But my body became a source of pain and frustration. At times, it was so painful I wanted to be amputated from it.

The pain was one kind of betrayal, but the lack of control over my physical appearance betrayed me further. I didn't want to be associated with useless limbs, claw hands, messy hair, and no lipstick. Nothing about my appearance felt right. I usually identify as "writer" or "dancer" or "croissant lover with red lipstick" before I identify as "someone who can walk" or "someone who has taken a shower," but I deeply missed those baseline identities. Nothing about me looked or felt like the person I'd spent my life creating myself to be. I had put so much effort into finding my style, my hobbies, my career. Now I couldn't even hold a pencil.

Can you still call yourself a writer if you can't write your first name?

I thought about the identity I'd created and wondered if it was still real. I thought about my intention for the year, thanksgiving, and wondered if that was still real. It occurred to me that my identity and intentions had not been picked for me, but rather what I had chosen for myself. After weeks of cursing the unfairness of life and all that had been taken from me, I resolved to reclaim what was mine.

In many parts of the world, pomegranates symbolize abundance. Abundance became my focus in the hospital. *My life doesn't end here*, I told myself. *In many ways, it begins here.* My physical therapist said that she was almost envious of people who recover from the disease. Their happiness is so deep and their perspective panoptic. They are in love with riding the bus and walking to the drugstore and doing cardio and bummer chores like emptying the dishwasher. Abundance means *more*: there was more happiness, more creativity, more adventure, more life to be had. In my most optimistic moments in the hospital, I knew this illness was a hiccup and not a limit; there was so much more for me.

When my physical therapist lifted up my arms and slowly stretched them in different directions, I felt like I was dancing underwater. I'd pretend I was a mermaid doing flamenco, and it was as close as I could get to feeling like my true self. For a few minutes, I looked graceful. I could still convincingly call myself a dancer even without being able to move my legs.

LiFE iN 3 AcTS

1. PLaNT

2. HaRVEST

3. ENJoY / SHARE

Healing The BoDy, MiND, oR HeaRT is NoT a LiNEAR PRocess.

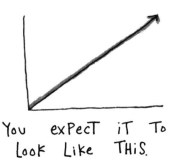

You exPecT iT To look Like THiS.

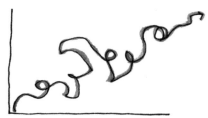

IT's REALLy MoRE Like THiS.

YoU MiGHT SeeM FiNe To OTHeR PeoPLe WhiLe STRuGGLiNG iNSiDe.

GLAD To See You'Re BouNciNG BACK!

WeLL...

AND TRYiNG To EXPLaiN How You FeeL CaN Leave you MoRe iSoLaTeD.

I'M ReaLLy HaViNg a HARD TiME.

I GoT The WRoNG LaTTe oRDeR ToDAY So I GET iT.

· 130 ·

L I N G

IT CAN BE EASY TO STAY ISOLATED
WHEN YOU FEEL LIKE NOBODY UNDERSTANDS YOU,
BUT THERE ARE MANY VESSELS THAT CAN
BRING YOU TO THE WORLD AND THE WORLD TO YOU.

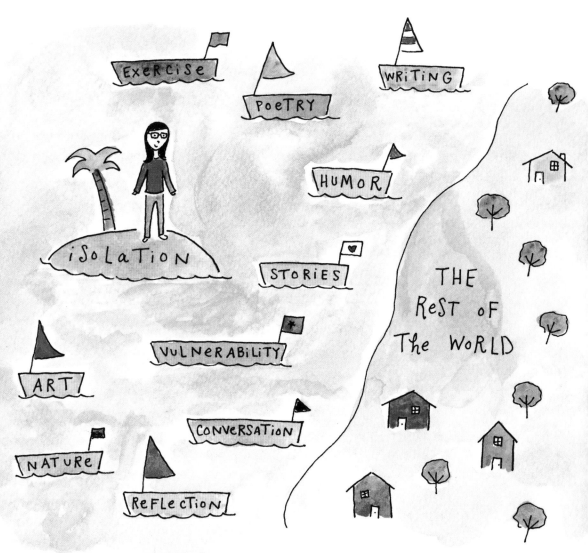

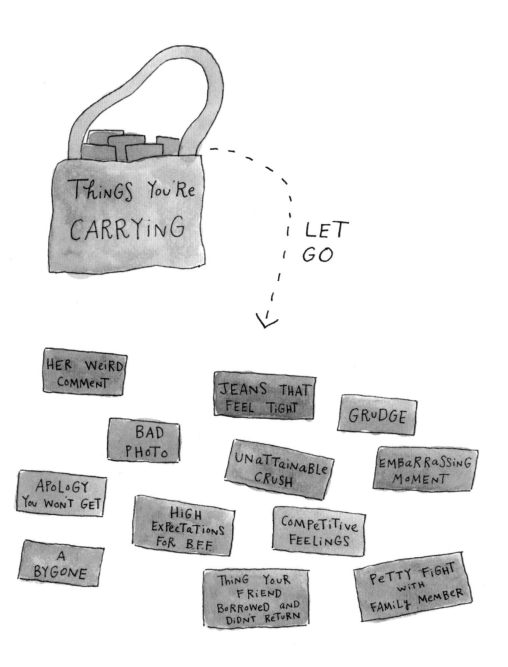

THINGS YOU'RE CARRYING

LET GO

HER WEIRD COMMENT

JEANS THAT FEEL TIGHT

GRUDGE

BAD PHOTO

UNATTAINABLE CRUSH

EMBARRASSING MOMENT

APOLOGY YOU WON'T GET

HIGH EXPECTATIONS FOR B.F.F.

COMPETITIVE FEELINGS

A BYGONE

THING YOUR FRIEND BORROWED AND DIDN'T RETURN

PETTY FIGHT WITH FAMILY MEMBER

FORGIVENESS

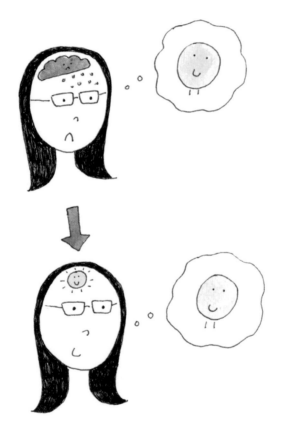

HiS MOOD DOESN'T CHANGE,
BUT MINE DOES.

Chapter 7

Discovering Yourself

GROWTH

LOSS

REJECTION

HEARTBREAK

DISAPPOINTMENT

FAILURE

CHALLENGE

ENCOURAGEMENT

HOW TO BECOME an ADULT

* GIVE YOUR PERSONALITY SOME BALANCE.

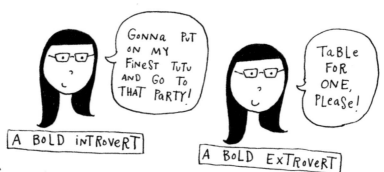

A BOLD INTROVERT

A BOLD EXTROVERT

* GIVE YOUR DIET SOME BALANCE.

* GIVE YOUR FRIEND GROUP SOME BALANCE.

* GIVE YOUR ATTITUDE SOME BALANCE.

RISK · TAKING

RISK	POSSIBLE OUTCOME	WORST-CASE SCENARIO
Going To a Wedding Alone	Solo Photo Booth Pictures Make Great Profile Pics	Solo Dance Floor Pictures Will Grace The Internet
Chopping Off Your Hair	Someone Will Mistake You For a French Model	Someone Will Mistake You For a French Schoolboy
Finding Roommates Online	One Will Be a Baker	One Will Be a Taxidermist
Taking A New Class	You'll Be The First Person To Mince Garlic Correctly On The First Try	You'll Be The First Person To Start a Kitchen Fire By Mincing Garlic
Making A New Friend	They'll Ask You To Share Their Wine	They'll Ask You To Help Them Move

MileSToNeS

When I was a kid, I used to draw invitations for my future wedding, dated with the year I would turn twenty-eight. As a fourth grader, I thought twenty-eight was the perfect age to get married, and I maintained my stance until age twenty-seven.

Instead of settling down at twenty-seven, I discovered my youth. While many of my friends were beginning to relish a Friday night in with a movie, red wine, and a bar of dark chocolate (growing older means paying more attention to heart health, after all), I was beginning to indulge in nights out. I would go on a date with anyone who took my phone number on the dance floor and spent a good amount of my very small salary on miniskirts and concert tickets. My friends, who had collected their clubbing stories during their college years, told me I was aging backward.

It rang true; I had been far more of a cautious homebody in the past. Suddenly, serious relationships seemed stifling to my carefree lifestyle, as did the stuffy office jobs of my peers. I felt lucky that I could go out on a Tuesday night and come into the boutique where I worked at noon the next morning, trusting a green juice to do whatever a green juice is supposed to do. I was enjoying my experiences so much that I temporarily let go of my quest for purpose and

instead set out on a quest for the perfect crop top. I was facing the sunshine and living in the light, like one of the well-watered plants that sat on my fire escape ladder.

I only felt a subtle ache as I approached my twenty-eighth birthday, wishing that a few of my life categories had more gold stars or that some more life milestones could be checked off. This ache was swiftly relieved when a new boyfriend came into my life—a hip graphic designer named Alejandro who brought me to chic events like fancy auctions and warehouse parties. The shine of a new relationship cast the rest of my life in a romantic glow: my retail job was a fledgling fashion career, my dismal financial situation was poetic, and my tiny studio apartment furnished with free hand-me-downs and tattered concert posters was adorable. I mistook my newfound youth as an excuse to be a little ridiculous, and my newfound boyfriend as an excuse to neglect the less appealing parts of my life. I was in awe of his friends with creative careers and cohesive living room décor, but I figured these things would come for me eventually, and in the meantime I'd just enjoy his midcentury modern couch and other people's art shows.

Alejandro and I broke up the week before my dad died. A week after that, I went to the doctor for a checkup and found out that I'd have to have minor surgery that would take six weeks to heal—and it would be painful. I felt like I'd just fallen through the flimsy net of stability that was holding me above ground into a mud pit twenty feet below, and I didn't have the muscle strength necessary to get back up to dry land.

The mire is where lotuses grow. At least, this is what friends told me as I confessed that I had found myself at rock bottom.

I sat on my bed the evening after my surgery, looking around my apartment, where I knew I'd be spending most of my time over the next few weeks.

It bothered me how my posters were fraying. I felt like cracking open a box of art supplies I'd bought months ago, but didn't even have anywhere in my studio to sit and use them. My apartment was the perfect place to plop down and sleep after a long night of dancing, but it was not a place to begin making my new life.

Since I'd be spending so much time there in the coming weeks and didn't want to mope through all of them, I thought of things to do that would bring me joy. I've always liked drawing, so I wanted to do more of that. It would be nice to learn how to play my dad's old guitar. I decided that now would be a good time to learn how to cook. I made a list of the steps I'd need to take: (1) Order a sketchbook. (2) Find a guitar teacher who could come to my apartment. (3) Watch cooking videos.

Then I thought about creating my ideal environment for my new hobbies. I'd been meaning to get a loveseat forever, so I'd make that my next big purchase. I would frame my posters, or maybe get some new funky art that I genuinely liked now that I didn't have to impress my arrogant designer boyfriend with forced minimalism. If I bought some colorful pots for my plants and some patterned dinner plates, my apartment would begin to feel a little more like a vacation to Mexico, and why wouldn't I want to feel like that all the time?

"Why wouldn't I want to feel like that all the time?" is the question that began permeating every category of my life. Once I made a decision to make my apartment more colorful and therefore more "me," I started making other seemingly small decisions that had a profound effect on my happiness: eliminating social events that felt like obligations, only doing exercise that didn't feel like punishment, and playing around with my skin care routine so it felt more like a treat (than a chore) at the end of the day.

With every change, I took a step toward my own happiness, and I strengthened the muscles that would lift me out of the place where I thought myself to be stuck. The decision that bulked me up the most was the one to draw one illustration a day and post them on Instagram to keep myself accountable. After a month of keeping my little project secret, I let a few friends know, and then I felt even more accountable to do it. I'd sprint home from dates at 11:55 P.M. to make my self-imposed midnight deadline, and it was consistently the most delightful part of my day. It was a simple way to process my experiences, but it

was also just a fun thing to do—color in the pen lines with vibrant paints while relaxing on my new yellow loveseat.

After a few months of drawing, I went up to New York to sell my prints for the first time at a pop-up art sale. I felt like I was overcharging for selling $10 originals, but strangers bought them and complimented them and often laughed out loud at them (in a good way).

At first I gave an unnecessary disclaimer to everyone who walked by: "I'm not a real artist, this is just for fun." By the end of the second day, I had sold most of my inventory and stopped apologizing for being an amateur. I thought about what it means to be a real artist, and it occurred to me that an artist is, by definition, someone who makes art. I was certainly doing that, and selling it in SoHo, no less. None of my customers needed to know that I had never taken an art class. They didn't need to know that my watercolor set was intended for children and I had bought my paintbrushes for $3 at the drugstore. None of them could tell that I had recently found myself in a mud pit and that my greatest accomplishment was bringing myself out of that mire and into the world with my own strength, becoming more creative, curious, engaged, and productive in the process. They just liked what I was doing as much as I liked doing it.

When I turned twenty-nine, I realized with a laugh that I had missed my marriage deadline. Putting a wrinkle in my own self-imposed plan was freeing in a way I didn't expect it to be. Because my life didn't look at all how I thought it would, I was able to ditch the arbitrary adulthood checkboxes and go rogue, creating days and routines and a new set of priorities that I actually wanted. I was no longer borrowing coolness from Alejandro or envying lifestyles that felt out of my reach; I was too happy with mine even to care.

That year, I drew a different invitation: to my first ever solo art show. All my best friends were there, and I wore a short white dress. There was cake, and many "congratulations" from loved ones, and I checked off a milestone I hadn't even known existed.

New YORK, New YORK

FIRST TIME
I FELT AT HOME

FIRST
TIME MEETING
My BEST
FRIEND

FIRST
Time FALLING
in Love WITH
ART

FIRST
SACK DRESS
PURCHASE
(I NeveR
Feel MoRe
ADULT Than
WHEN WeaRiNG
DRAPeY CLOTHeS)

FIRST TIME
FeeLiNG inspire
To MAKE ART

FeLT Like a
Movie ADULT
at This
HiDDeN
JAZZ
CLUB

FiRST FANCY
ResTauRaNT DATe /
FiRST CockTaiL ThaT
WaSNT a VoDKa ToNic

FIRST Love
AFFaiR WiTH
a CiTY

FiRST TIME
FeeLiNG
÷iN LoVe÷

FiRST TIME
I REALiZeD
I WAS
The O NLY
PeRSoN WHo
CoULD BRiNG
MYSeLF oUT oF
SAD TowN

WHERE I BECAME AN ADULT

ADULTHOOD

SPLIT a CHECK WiThouT FeeLinG a NEED To wRiTe CReDiT CaRD #s and ExacT AMouNTS on The Back of The ReceipT

Mari-
$7.67

GeT iNTo CoCoNuT oiL

KeeP a LiVinG THinG ALive and HeaLThy (BesiDeS MoLD)

ADULTHOOD GoAL-MaKinG

DUMP \longrightarrow DATE

GuY WHo JuDGes You oN YouR MuSiC TASTe

♪BLUES♪
GuY WHo iNTRoDuceS You To New MuSiC

TRADe ThiS LuNCH \longrightarrow FoR ThiS

CHiPS CHoCo

Made with LoVE
FoR ME FRoM ME

GOALS

STOP CRINGING
WHEN ASKED,
"WHAT DO YOU
DO?"

FIND a GUY
WHO WILL TAKE
PHOTOS OF ME AND
CAPTION THEM #GODDESS

OCCUPATION:
ASPIRING
OPERA ENTHUSIAST

FIND a STYLISH
FRIEND WITH THE
SAME SHOE SIZE
AS ME

GET RID OF \longrightarrow

SOMETHING
THAT DOESN'T
WORK QUITE
RIGHT

INVEST IN

SOMETHING
THAT MAKES
a CHORE a
PLEASURE

DON'T BORROW \longrightarrow

FOR MEN
ROOMMATE'S
SHAMPOO

DO BORROW

WHEN I WAS YOUR AGE...
A WISE PERSON'S
CAREER ADVICE

STOP
BLAMING EVERYONE ELSE \longrightarrow

THIS IS SOMEHOW
MY 6TH-GRADE
BIOLOGY TEACHER'S
FAULT.

START
TAKING MATTERS INTO
YOUR OWN HANDS

FIRST, THERAPY.
THEN A
WOODWORKING
CLASS!

THiNGS EVERY
SHOUL'

A POWER
OUTFIT

A PiECE OF
ART
(eveN iF You Made
iT YouRSELF oR HaD
To CoMMiSSioN YouR Niece)

A SONG THAT
GiveS You STReNGTH

I WAS BoUGHT
oN A SweDiSH
HiLL ToP.

A PoSSeSSioN
THAT TeLLS A
STORY

· 146 ·

30-Year-OLD HAVE

A GO-TO MEAL
FOR ENTERTAINING
GUESTS

A BEAUTY
PRODUCT YOU LOVE

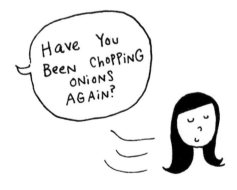

A SIGNATURE
SCENT

AN ACHIEVABLE
GOAL

FRIENDS WHO REALLY HAVE IT TOGETHER

The one who can perfectly wrap oddly shaped gifts

THE ONE WHO HAS MASTERED ACCESSORIZING

THE one who knows about it first

THE one whose nails arent chipped

The one whose mail app never has this red circle

The one whose purse doesnt harbor all of this

ANATOMY OF THE
LaDY I WaNT To Be

IN APPROX. 20ISH YEARS

A LIBERATING HAIRSTYLE

A PERFECT SKIN CARE ROUTINE

NON-IRONIC BIG BLUE GLASSES

THE PERFECT LIPSTICK COLOR AT LAST

JEWELRY GATHERED FROM TRAVELS

A SIGNATURE MUSKY FRAGRANCE

COMFORTABLE ALL THE TIME

BRACELETS MADE BY ARTIST FRIENDS

THERE'S A PAIN AU CHOCOLAT IN HERE

STORIES TO TELL OF ADVENTURES, INTERNATIONAL LOVE AFFAIRS, AND CALM, QUIET MORNINGS

MAGNETIC KINDNESS RESILIENT SPIRIT FUN-LOVING

FABULOUS SKIRT FROM A CHIC BOUTIQUE IN MEXICO CITY

LEGS THAT KNOW MANY DANCES

SHOES THAT MAKE A NICE CLICKING SOUND WHILE WALKING

FINDING YOUR PERSONAL STYLE

1

WHEN DEVELOPING A PERSONAL STYLE, IT'S HELPFUL TO REMEMBER THAT YOU ALREADY HAVE ONE.

Personal style is equal parts taste and function, and you definitely already have taste. Name a couple of favorite movies, bands, and works of art. See? Taste. But function is the less sexy half—the part that is dictated by where you work, how you spend your time, your climate, and your comfort threshold. Style is where these two merge.

2

THERE'S A BIG DIFFERENCE BETWEEN FASHION AND STYLE.

Fashion is an art that is notoriously difficult to keep up with because trends change seasonally, whereas style is impacted by much longer-lasting factors. Style is affected by religion, politics, culture and subculture, weather, body type, profession, upbringing, blah blah blah—things that magazines don't dictate.

Think about fashion versus style in comparison to food consumption. You eat every day; you wear clothes every day. There are some days and some occasions when you put more thought into your meal or outfit than others. Some people, cloyingly called "foodies" or "fashionistas," are into food or fashion as a hobby.

High fashion is like a five-star restaurant dish that shows innovation and expertise. A plate of soft-boiled quail eggs with a side of liquid nitrogen ice cream will look exquisite and show a great deal of culinary competence, just as so many gowns and suits on the runway look like moving works of art. However, there is something to be said for hot-dog vendors, deli owners, and your grandma's kitchen. They may not make particularly progressive dishes, but their food is still delicious and meaningful. Their food may not be fashionable, but it has style. It is unique to them, and it is recognized as something special.

You can be stylish without being fashionable. Once you have a good grasp on your personal style, you can take it to any area of your life. For example . . .

3

EXTEND YOUR PERSONAL STYLE TO DECORATING YOUR HOME.

Amid heartbreak, grief, and surgery recovery, I spent a lot of time in my apartment—more time than I ever had before. That means I had to get my act together and make it a place where I really wanted to spend time. I put a lot of effort into it, which mostly meant printing photos from years ago and replacing my collection of free forks and knives with actual silverware. Decorating my apartment during my grief was the experience that made me realize I could make my life. I couldn't control everything, but I could at least curate the way it looked.

I am drawn to anything evocative—any piece that gives me a strong feeling or memory. A great compliment for me, whether it's on my outfits or my apartment, is "This reminds me of . . ." The ability to create a feeling or nostalgia for someone else is a mystical power that we can all, knowingly or unknowingly,

exercise. I'll never forget when an old man stopped me on the street when I was in college and said, "Wow, that's exactly how my mother used to dress." I took it as a big compliment that I was able to give him a memory.

I want people to come into my apartment and feel like they've been there before because it evokes some memory of travel or childhood or a Miami hotel lobby. I want to come into my own apartment and feel all the things I love.

Because I love traveling so much, it only makes sense to try to replicate that experience in my home. For example, I try to eat on my fire escape a lot because most of my favorite memories from traveling involve eating outside in the sun or under strings of lights at night. I also wanted my kitchen to feel like the kitchens I've known and loved in foreign countries—hodge-podge corners cluttered with ceramic creamers, bright coffee makers, mismatched glasses, plates painted the color of lemons, and trinkets from island villages and offbeat landmarks. I can't travel every day, but I can fill my home with things that simulate that same sense of wonder, curiosity, and cheerfulness that I get when I'm visiting a new place.

4

START COLLECTING ART YOU LOVE.

A word about my art. I own art. Three pieces of art. Well, two and a half, depending on your definition of art. So what is art?

a) After a particularly rough surgery involving the removal of some ominous cells from my cervix, I was wandering around Washington, D.C., in a haze and found a portrait of a Spanish dancer on the wall of a junk store. Now that dancer is my roommate and role model. She reminds me that women endure so much pain, and must do so with strength and grace. But in turn, we are gifted with intuition, empathy, and sensuality.

b) I bought a collector's print of a poster for a Miró exhibition in Paris in 1974. My favorite part of the poster is that it was printed with the wrong day, so someone had to put tape over the word *Samedi* (Saturday) and replace it with *Lundi* (Monday). I like thinking about that person in 1974 who probably thought it was a huge mistake at the time, but look, now we're in the future and I'm sure nobody remembers except me, because I look at it every day and I'm totally endeared to it.

a. b. c.

c) I keep a set of acrylic neon cubes on a shelf. Talk about evocative. They remind me of a million things, but mostly rich West Coasters in the '90s who wore orange blazers and lounged among brightly colored Lucite. I think these cubes are outrageously stylish in the same way that a hot pink jumpsuit or gigantic hoop earrings are outrageously stylish; the way that Grace Jones, Princess Diana, Whitney Houston, and David Bowie were outrageously stylish. They are the bright purple shoulder pads of sculpture, and I love the way they contrast with the rest of my vintage-meets-boho East Coast décor. They're like if Prince walked into an American Girl catalog. They bring a much-needed pop of weird to my apartment.

<p align="center">5</p>

SPEND MONEY ON THINGS YOU ADORE.

Spending money sucks because then you don't have as much money as you had before. But another way to think about it is that you get to cultivate and invest in the things you cherish. Spending money shouldn't make you feel guilty; it should make you feel grateful. You get to select something that will make you happier and more expressive. Keep this in mind when you're buying anything. Even food! You know you need to mix some vegetables into your diet, but don't do it without consideration. Which vegetables do you find most delicious? Which colors of vegetables are your favorites? Buy those!

If you need a winter coat, but don't really want a winter coat, do your research to find a winter coat you're crazy about. Every time you see that coat, you should feel a little buzz of excitement—either from the color or the design or the feeling of plunging your hands into the satin pockets. Shopping should never be a chore; it should be a delight, acknowledged as a marvelous privilege. Sometimes it's purely functional, yes, but even functional can bring you joy.

PERSONAL FOOD GUIDE PYRAMID

CRUMBS STUCK TO MUFFIN WRAPPER

KiMCHi

NuTELLa

SLeeve oF CRackeRS

WiNe FROM UNUSUAL Box SHAPe

ROSÉ

TacoS

CUSTOM SaLaD BowLS

PoT oF CoFFee

RANGE OF EXERCISE CLASS FEELINGS

ARRived EaRLY aND GoT THE BeST SPoT

NEW LeGGiNGS Looking So GooD

MoRe THAN HaLFWAY ThRoUGH!

I THiNK I HaVe WiNe LeFT at HoMe!

ThaT GuY iS KiNDA CuTe

SoN G ReMiNDS Me OF My EX

Io MoRe OF THeSe??

How iS SHe DoiNG That So EASiLY?

ThaT GuY iS SeeiNG Me aT MY SWEATiEST

SAMPLE MONThLy BUDGeTS

CANDLES SCeNTeD LiKe
EVeRY BAKeD GooD

"SELF CARE"

(NaiL PoLiSH, CHaiR MaSSaGe
AT THe MALL, BLoWoVT,
NeW BooK, 7 NeW
JouRNaLS, ReD WiNe,
MaGaZiNe, FReNCH SoAP,
CAT)

VaLeNTiNe's
DAY
PREP
(eveN/
eSPeCiALLy
WHiLe
SiNGLe)

DARK
WiNTeR
LiPSTiCK
exPeRiMeNTaTioN

FEB

DiSCoUNT VaLeNTiNe's Day
CANDY

BiLLS aND
CRAP LiKe THAT

NeW CoATS
FoR EVeRY 5° CHANGE

FARMERS' MARKeT
PRoDUCE

BiLLS aND
CRAP LiKe
THAT

iCED
CoFFee

VaRiouS
BeVeRaGeS
oN
VaRiouS
RooFToPS

SaNDALS
FoR EVeRy
oUTFiT

JuLY

BaNDAGeS
FoR SaNDaLS

The MANY
PaiRS oF SuNGLaSSeS
I wiLL LoSe

HaiR ReMoVaL
TooLS
(0% BuDGeT FoR
THiS iN WiNTeR)

I RECOMMEND SETTING UP
AUTOMATIC MONTHLY DEPOSITS.

TaBS OPeN

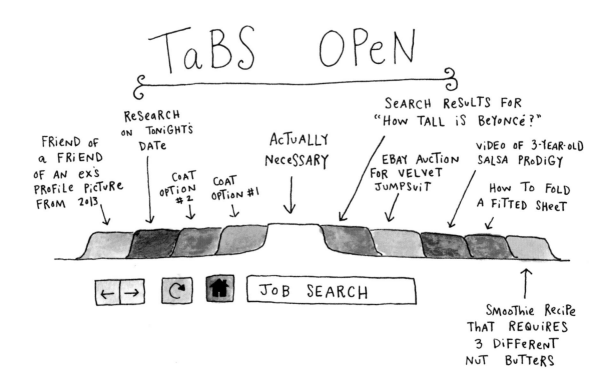

FRiEND oF a FRiEND oF AN ex's PRoFiLe PicTuRe FRoM 2o13

ReSeaRCH oN ToNiGHTS DaTe

CoAT oPTioN #2

CoAT oPTioN #1

AcTUALLY NeceSSARY

SeARCH ReSuLTS FoR "How TALL iS BeYoNce?"

EBAY AucTioN FoR VeLVeT JuMPSuiT

ViDEO oF 3·YEAR·oLD SALSA PRoDiGY

How To FoLD A FiTTED SHeeT

JOB SEARCH

SMooThie ReciPe ThAT REQuiRES 3 DiFFeReNT NJT BuTTeRS

SKILLS I WISH I COULD ADD TO
MY RÉSUMÉ

* COLLABORATION: COLLABORATES EFFECTIVELY OVER GROUP TEXT TO PLAN DATE OUTFITS

* STRESS MANAGEMENT: CAN APPLY LIPSTICK WHILE BEING WATCHED

* MULTITASKING: CAN CARE ABOUT REALITY TV AND CURRENT WORLD EVENTS

* ADAPTABILITY: ABLE TO QUICKLY CHANGE BRUNCH ORDER IF FRIEND TAKES MINE

* TIME MANAGEMENT: CAN RE-CREATE EFFECTS OF SHOWER IN 1 MINUTE WITH DRY SHAMPOO

* SELF-STARTER: MADE A SCARF INTO A BEACH COVER-UP ON VACATION

* EVENT PLANNING: JUST LOOK AT THESE PHOTOS FROM MY 26TH BIRTHDAY PARTY

CHAPTER 8
FINDING YOURSELF

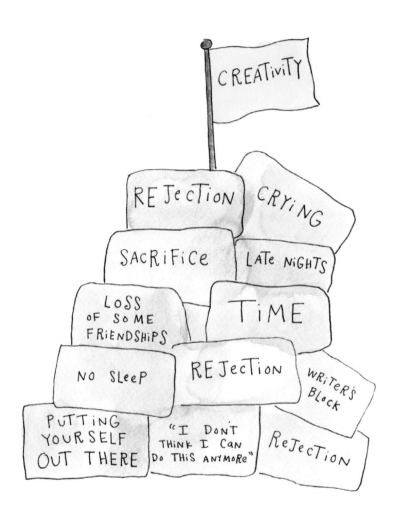

IDeNTiTY

ACCORDiNG To oTheR PEOPLe

PERSoN iN MY LiFE	WAY THey iDeNTiFy ME
COWoRKeR	The oNe WiTH THe SPARKLe TiGHTS
TaRoT READeR ACQUAiNTaNce	The uLTiMaTe LiBRa
BARiSTa	DouBLe SHoT oveR iCe
TiNDeR Date	THE oNe Who WOULDNT SToP TalkiNG aBouT The WHALe DoCUMeNTaRY
EX	PoSSeSSive, GooD GiFT- GiveR
MoM	FuLL oF PoTeNTiaL
GRouP oF FRieNDS	THe oNe WiTH The SNACKS

WHAT SHAPES YOUR
iDENTiTY

PARENTS,
MoRe Than one
CARes To ADMiT

ALL The CooL
STRaNGeRS You've
Seen on BuSeS

AN aFTeR-SchooL
SPeciAL THAT
ReaLLy STuck
WiTH You

YouRe
MiAMi!

"WHiCH CiTY
ARe You?"
QuiZZeS

The SoNGS
on YouR FiRST
MiX CD

The PeRSoN oN
THE PoSTeR iN
YouR RooM GRowiNG
uP

FINDING YOURSELF = CREATING YOURSELF

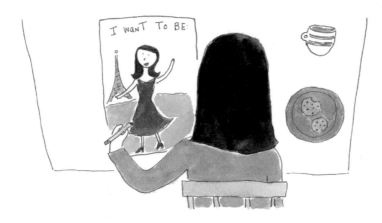

INSPIRATIONS

LOVE ⟶ COUPLES WHO HOST COOKING SHOWS TOGETHER

WE LOVE WINE AND EACH OTHER!

CREATIVITY → ART ON ANCIENT CERAMICS

LIFE ⟶ TILDA SWINTON AS A CONCEPT

FALL FASHION ⟶ EDWARD GOREY CHARACTERS

CAREER ⟶ POWERFUL '80S BOSS WITH SHOULDER PADS AND AN ASYMMETRICAL PERM

BeloNGiNg

I'd been wanting to kiss my housemate since I had arrived in Rio. We shared a hundred-year-old pink mansion on a hilltop in Rio's former-slum-turned-hipster neighborhood, owned by an artist couple with paint splatters on all their clothes.

Actually, I'd been wanting to kiss anybody since I had arrived in Rio. I was there in the dead of South American winter, which is to say, a gorgeous time of year. The mornings were chilly enough for hot coffee and thick socks, but the afternoons were warm enough for crop tops and frozen açai bowls. I started every morning eating fruit in the kitchen with bossa nova music on the radio and ended every night at the beach watching the sun drop into the ocean. Perhaps Rio is so sexy because everyone wants to make love to the city, so they project their desires on the closest human.

My housemate was flying out and suggested we take a cab up the hill in the morning for a view of the city before he left. He was an architect from New York who was always scribbling notes in a small black Moleskine notebook, and exactly the brooding mystery I had been looking to leave behind in the United States for the open-hearted men of Brazil. But Rio had brought out his joie de vivre and we swapped tips about dance parties in the streets, secret caves that boomed with live music, and the best and cheapest beach cocktails.

The cab twisted through our neighborhood, which was a steep jungle filled with mural-covered walls and mansions that had been converted into cheap apartments for the musicians who kept the streets awake at night with their impromptu jams and block parties. The driver let us off at the highest point—a helicopter landing pad with no railing or even marked boundaries. The edges of the area dropped sharply to a slope; looking down made me woozy. But I couldn't imagine a more beautiful viewpoint in Rio, and we had it completely to ourselves.

We sat on the edge, our feet dangling over the sea. We were quiet, as though we were together at a museum paying our respects to the master-pieces in front of us.

"These condors are beautiful," the architect said, after a few minutes of dutifully considering the water, the sky, the hills surrounding us.

"Oh, is that what those are?" I asked. "I thought they were vultures. Wait—are condors related to vultures?"

"I think they're elegant vultures." They had the same low-flying pattern as vultures but looked far less ominous, like they were just out for a morning swirl around the mountain.

"They're so . . . ," I said, mesmerized.

"Majestic," he concluded.

"What's the thing about condors?" I wondered aloud. "Aren't they really ugly? Or is that an albatross?"

"I think they're really awkward on land—like, they're bad at walking."

"Oh, yeah, they're really clumsy, right?"

"Yeah but in the air, they're . . . gorgeous creatures who command the sky."

With Guanabara Bay spread under us like a million tiny sapphires, nothing about his statement seemed stilted. We were both being so careful with our conversation, so as not to disturb the splendor that surrounded us. We talked in verse, in metaphor, in abstracts. We revealed poetry about ourselves in between long and reverent silences.

"I think I'm a condor." I disrupted the silence a little too earnestly.

I liked the idea of a creature whose features didn't make sense on land but all came together for a majestic flight. I felt like so many of my insecurities went away when I traveled, and the things I'm most self-conscious about became things that helped me be a better traveler. My tricky-to-pronounce name made more sense in any country other than the United States, my independence was a great asset rather than something that isolated me, my eccentric way of dressing camouflaged me, and my quick-paced walk made me assertive rather than aggressive, like I belonged.

The architect's flight was approaching; he looked at his watch and gave me a look of reluctance that I interpreted as longing.

"Should you go?"

He nodded.

We looked at each other for a while and I broke eye contact by asking a knowing question. "Are you sad to leave?"

"So sad. But really glad I met you." He put his hand on my knee. This look was familiar: The look that makes the horrors of dating and uncomfortable first dates well worth it. The look you only get once because after you've kissed, this look can't be replicated.

I imagined a condor flying for the first time. Surely they're tremendously awkward in their youth, stumbling around in the ditch where they are raised, tripping over their feet. *Is this what life is like?* they may wonder to themselves. Then, one day, without knowing it, they intuitively move their shoulders and their wings spread. The wind carries them into the sky and they find themselves triumphantly gliding far above the dirt that until that moment had been their whole world.

Oh, this is what I'm for. This is what life is supposed to feel like, the teenage condors think to themselves.

In the throes of heartache and grief, I had felt stuck in the awkwardness of not knowing quite how to move forward. I felt bound to the ditch for so long, unable to see what it looked like from above. At times it felt like I'd never get out, and I got used to the constant tripping and stumbling around. It didn't feel like life should be, but it was how my life was. I accepted it.

But over time, I strengthened into a different version of myself. I had new muscles, a new way of moving in the world. My creativity and resilience and courage had grown. All this growth made me feel worthy of a new kind of romantic love—one in which I was far less concerned about whether I was worthy of a man and much more interested in his worthiness of me.

When I was with the architect on top of the mountain, I belonged with him, I belonged in Brazil, I belonged far above the ground. *Oh, this is what I'm for.*

He had an hour to catch his flight, but he put his arm around me and we relaxed on our perch. I was soaring.

RiO de JANEiRo, BRAZiL

Fell in Love with CHEESE BREAD

Fell in Love with This FLAMINGO-PINK MANSION

FeLL in Love with The SMELL OF TROPICAL RAIN

FELL in Love with The View OF THiS MOUNTAIN FROM The BEACH

Fell in Love with HOT PINK FLoweRS

FELL in Love with STReet Açai SoLD in PapeR CUPS

Fell in Love with The CiTY MoNKeys who STEAL Snacks and BackPacks

Fell in Love with The WORLD oN ThiS BEACH

FELL in Love with This DRESS AT a BouTique in iPaNeMa

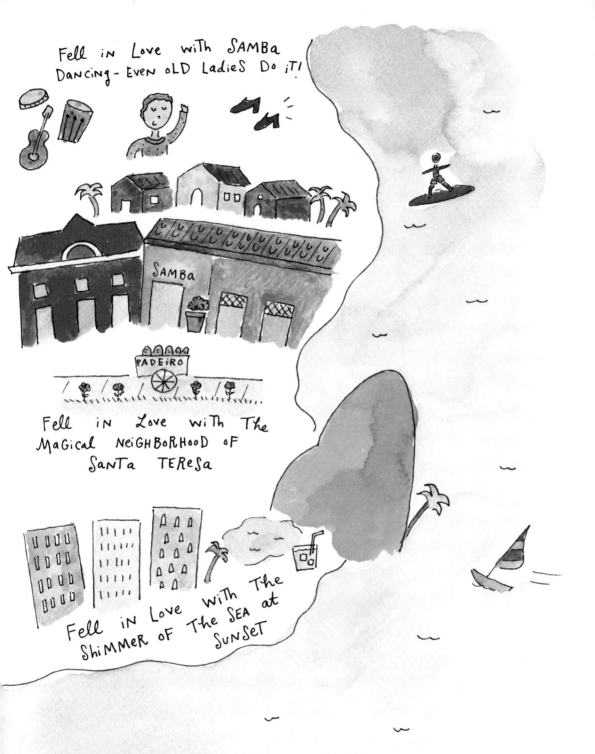

Fell in Love with SAMBa Dancing — Even oLD LadieS Do iT!

SAMBa

PADEiRO

Fell in Love with The MaGical NEiGHBoRHooD oF SanTa TERESa

Fell in Love with The ShiMMeR oF The SEA at SunSeT

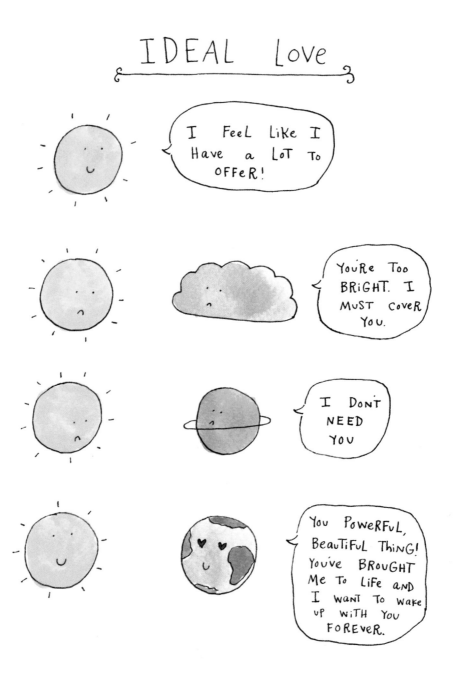

DaTiNG YouRSeLF

WEAR DaRK
LiPSTiCK aND oRDeR
The 2nd MoST
ExPenSive WiNE oN
The MENU

BuY a CHEMiSe
FoR RoMaNTiC
EVENiNGS at HOME

PiCK a 7-SEASoN
SHow To WaTCH
EveRY NiGHT

PUT oN AS MUCH
PeRFuME aS You
WANT

REALiZe How
MuCH You CaN
LiFT ALoNe

oRDeR The
THiNG NO oNE
EveR WaNTS To
SHaRe WiTH You

HEART MiND GuT

ANaToMy oF aN ADuLT

My twenties were a nonstop adventure in learning lessons, and some of the lessons were more fun than others. For example, I learned how to apply lipstick. I got to know New York much better. I learned the Berlin subway system, and how to say "Excuse me, where can I dance?" in German. I refined my sneaker collection and got my hair color exactly as dark and red as I wanted it for ultimate czarina effect.

Then there were the other lessons. These are the ones that took a little more time:

1

MAKE FRIENDS WITH HEARTACHE.

You've felt it before. You'll feel it again. Heartbreak is one of the trade-offs of getting to spend a precious few decades in this world. Never let the futile fear of it stop you from sending that text, saying it first, trying again, or letting it go.

2

STEP UP IN A TIME OF TURMOIL.

Most people, including me, don't know what to do when someone else is in crisis. It's confusing and risky to reach out to a friend when she's dealing with something life-twisting and unusual. The fear, of course, is "I don't know what to say," so you keep silent. You don't know what to do, so you do nothing. I get it, I do it, we all do.

This year, I learned how good it feels when people swoop in and risk vulnerability during your own tough times. I met a girl named Rachel once at a party. We chatted briefly, said "nice to meet you," exchanged ridiculous OkCupid stories, laughed over wine in plastic cups, and that was about it. A month later, when she heard through a mutual friend about my apartment fire, she sent me flowers and homemade brownies. It meant the world to me. She probably hesitated, thought, *This might be weird since we don't really know each other,* but she still made an extraordinarily kind gesture. I will never forget it. It made me want to be a bolder friend and a more generous acquaintance.

Lesson: It's never wrong to do something kind.

3

FIND YOUR EDGE.

I learned this in yoga. When we're in a balancing posture, we're encouraged to lean as far forward or reach as high up or bend as close to the ground as we can until we fall. Only then will we know where our limit is. If we don't tumble over, we won't know how far we were capable of going. When you don't let yourself

wobble around and fall on your head, you can only guess where your edge is, and it's almost always farther than you think.

I learned a lot about my edges at age twenty-eight. I can handle a lot up to a certain point. I found some of these points. I found them at my job, in my relationships, even in my outfits (paisley is my edge).

In yoga, there's a difference between pushing yourself and hurting yourself. A couple of years ago, there was a job I really wanted. The interview process for it was months-long and tough on my sensitive soul. There were moments during the interviews that were a good kind of challenging: I had to assert myself in a way I've never had to before. But there were also straining moments that wrenched into my insecurities rather than bringing out new strengths.

During the process, I found my edge. I fell on my head. I got up and said, "No, thank you, not for me." It was one of the best decisions I've ever made.

4

SHOW UP.

Show up for friends. Show up for yourself.

Show up at the dentist. Even if your appointment is at nine A.M. on a Sunday, and you stayed out late, and you'd rather go to brunch, and you're sick of doing the responsible thing, show up. Go there and get your gums cleaned and be grateful you get to do that, even if you definitely don't feel grateful.

Show up with stories to tell. Your whole life prepares you for the big moments, so go in confidently knowing you have years of experience to your name. This goes for interviews, dates, or any important conversations. It's ultimately about whether they're a fit for you than you a fit for them, so be funny and self-assured and wear hot pink if you feel like it. Don't hide the fact that your favorite sport is bocce ball and you're currently binge-watching *Golden Girls*.

Show up for work. Take charge of your responsibilities. Be honest. Ask questions. Work hard. Offer to help, offer to stay, but don't let it keep you from doing other showing up for your loved ones.

Show up to see friends and family. Even if you don't feel like it. Even if you don't like your friend's friends. Even if you don't have anything in common with one of your relatives. Show up for concerts on a work night, for sporting events you know nothing about, for that thing your friend is doing for her job that you don't really understand but it seems important based on how nervous

she is. Show up for your friend's birthday with the more expensive wine. RSVP and show up *on time*. People remember when you were there and when you weren't. Even the one you suspect doesn't even know your name—she does know, and she does care, and she will remember.

5

FIND A HOBBY YOU'LL HAVE FOREVER.

You may not always have the same friends or same relationship you have now, but *you'll* always be with you. As a new adult, now's the time to become the person you want to live with for the rest of your life.

One warm evening in Lisbon, at the height of my heartbreak, I was walking around feeling lonely and envious of the beautiful and life-loving free spirits near me. They were playing guitar, drawing, dancing salsa, and crocheting around trees with neon yarn. I didn't really have anything to contribute to the scene except to sit there with my water bottle and write in my journal. They couldn't have felt further away from my reality.

It occurred to me that I could build a bridge to that reality. I could actually make myself into a person who plays guitar on a warm evening in a park. It would begin with guitar lessons. I signed up for as many classes as I had time for to make myself into the adventuress I wanted to be. In essence, I began to create my adult self.

I decided I wanted to be a person who painted with watercolors for fun because it seemed like a really soothing activity, so I decided to make one illustration a day and color it in it with a cheap paint set I had left over from babysitting. I made myself an artist simply by making art.

The great gift of heartbreak, rejection, loss—of any challenge—is that it's the impetus to stop hoping you'll be happy someday and start making yourself happy now. Making yourself into an adult is this ongoing process of transforming your life experience into the person you've chosen to be.

Keep experiencing, keep challenging yourself, and keep having fun!

MUSEUM OF MY LIFE

BIRTHMARK

FAMILY PORTRAIT

CHOSEN FAMILY PORTRAIT

BUST OF
HEROINE
FROM FAVORITE
BOOK

TRAVEL
JOURNAL

GLASSES I
HAVE OWNED

FORK FROM
FIRST DATE

FIRST PIECE
OF JEWELRY I
EVER BOUGHT MYSELF

DIORAMA OF
CHILDHOOD
LAKE MEMORY

CReaTiViTy iS LiKe The BASiL PLaNT iN
YouR KiTcHeN WiNDoW. YoU PicK ALL The
LeaveS oNe NiGHT FoR A FeW TaBleSPooNS
oF PeSTo aND You Think, "THaT'S iT! No MoRE!"
You FiND THe NeXT MoRNiNG THat You
Have all NeW LeaveS— EveN MoRe ThAN
BeFoRe.

HOW TO
Make AN ARTIST

1. Take a SeNSiTive, CuRiouS LiTTLe WeiRDo WiTh AN inHeReNT DeSiRe To EXPReSS HeRSeLF.

oLá?

2. PuT HeR iN SiTuaTioNS WheRe SHE iS NoT 100% CoMFoRTaBLe So SHE iS FoRCeD To OBSeRVE.

3. GiVe HeR a PeN aND SoMe QuieT.

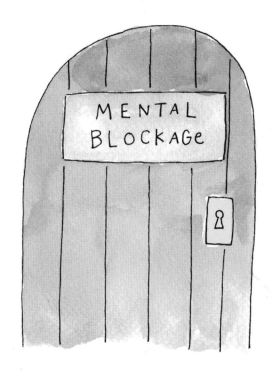

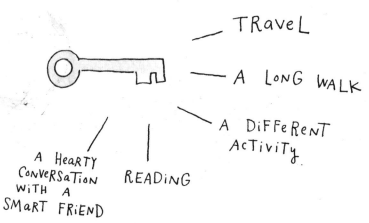

TRAVEL

A LONG WALK

A DIFFERENT ACTIVITY

A HEARTY CONVERSATION WITH A SMART FRIEND

READING

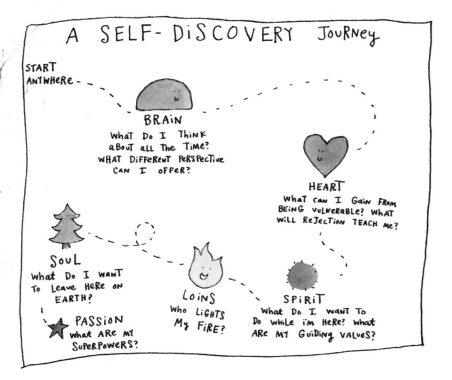

EveRy Day AdveNTuRes
That Have The Same EFFect as TRaveLing

EaTing BReakFast
on YouR FiRE EScaPe
whiLe WaTchiNG THe
SuN RiSE

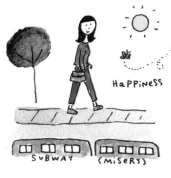

HaPPiNess

SuBWAY (MiseRY)

WaLKing ALL The
WAY To WORK

Having YouRSELF
a CRazy TuESDay
NiGHT!

(ROLLER RiNk iS a GReat
PLace FoR THiS)

TRYiNG
SoMeTHiNG
FuN + NEW
(aND PoST PHoToS
oF YouRSeLF DoiNG
iT!)

WEARiNG NEW
LiPStick.
FeeL Like
YouRe A
NEW WoMaN.

GeTTiNG To The CoFFEE
SHoP EARLY So You
CaN GeT a CaPPucciNo
≥FOR HERE≤

STEPS TO BECOMING AN ADULT

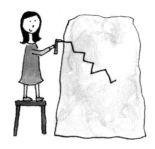

1. WORK WiTH What You Have:

 WhaT WORKS FoR MARBLe WON'T WORK FoR WOOD. You KNOW?

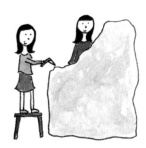

2. LET YouRSeLF BE SuRPRiSeD BY LiFe: YouR PRiORiTieS wiLL ChaNGe aND ThiS iS GooD!

3. BuT YOU Have THE FiNAL SAY: You aRe THe oNLY oNe WHo HaS To Live wiTH YouR DeciSioNS.

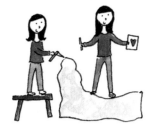

4. Love YouR CREATioN: You ARe THe ARTiST oF YouR owN LiFe! DiSPLaY iT, Take PRiDe iN iT, PoLiSH iT. iT'S aN EXHiBiTioN, NoT a CoNTeST.

HOW TO AGE FASTER:

I'M TOO OLD TO GO OUT

(I'M 25)

HOW TO GROW YOUNGER:

MIND IF I JOIN WHATEVER YOU'RE UP TO?

(ESPECIALLY WHEN I'M A LITTLE UNCOMFORTABLE)

A TREASURE HUNT
TO FIND YOURSELF

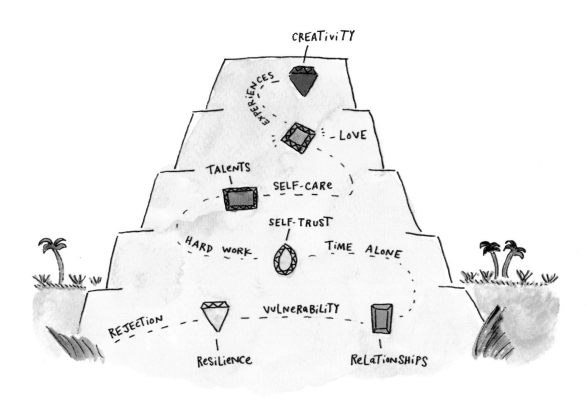

CREATIVITY

EXPERIENCES

LOVE

TALENTS

SELF-CARE

SELF-TRUST

HARD WORK

TIME ALONE

REJECTION

VULNERABILITY

RESILIENCE

RELATIONSHIPS

GRowinG UP

(CAREER EDiTioN)

WHAT MakeS ME

⸚ ME⸚ ?

A TIMELiNE

Childhood	FavoRiTe CoLoR
15-17	BAND T-SHiRT
18-22	MAJoR OR
	STUDY ABRoAD OR
	DoRM RooM PoSTeRS
23	PROFiLe PicTuRe
24	BoYFRiend (iN a BAND)
25	BoYFRiend (HaS A JoB)
26	MY SiNGLeNeSS
27	MY adVANceD CockTaiL (WiTH A TwiST!)
	ORDeR
28	MY New DReam CaReeR
29	ALL THe ReJecTioNS I've ENDuRED
30	HaiRCuT

ANATOMY OF AN
ADULT

MIND IS OPEN TO NEW EXPERIENCES

HAS THE CORRECT GLASSES PRESCRIPTION

WEARS JEWELRY THAT TELLS A STORY

ALWAYS BRINGS A BEVERAGE TO A HOME AND A PRESENT TO A BIRTHDAY PARTY

ASPIRES TO FINISH BOOKS BUT FEELS NO SHAME WHEN SHE DOESN'T

REMEMBERS TO BRING A REUSABLE BAG

TAKES HAIRSTYLE RISKS BUT DOESN'T DEFINE HERSELF BY THEM

CARES FOR HER SKIN

HEART IS OPEN TO POSSIBILITIES

HAS AN ARRAY OF FUZZY SWEATERS (APPROPRIATE FOR 3 SEASONS)

KNOWS WHAT TO SHARE (AND NOT SHARE) ON SOCIAL MEDIA. KNOWS WHEN TO PUT HER PHONE AWAY.

WEARS PANTS THAT LOVE HER BACK

BLISTER-FREE FEET (PREPARES FOR HEEL-WEARING WITH BAND-AIDS)

SHE'S BEEN PLACES

ACKNOWLEDGMENTS

 A BOUQUET OF DAISIES TIED WITH PINK RIBBON FOR MY ⸙SPARKLING⸙ AGENT AND DEAR FRIEND, CINDY UH at THOMPSON LiTeRaRy AGeNCY.

 The MOST COLORFUL HEAP OF WILDFLOWERS FOR My BRILLIANT, CARING, CREATiVE FRIENDS. Thank You FoR BEING The WiND BENEATH My WINGS SiNCe MY BLOGGiNG DAYS: SuSAN, KiM, iCCA, KiKi, CaiTLiN, JUMANA, JoE, THERESA, RoDRiGo, JANie, SaRaH, TiM, JoN, LauReN, JeSS.

A BLOOMING PLANT FoR ARTiSTS/WRiTERS WHo Have SHown Me SuCH GeNeRouS SuPPoRT: Dana, Liana, DaRYa, CHAD, ADRiANA, ADAM, JoANNA, BRené ♡, aND QueeN Zoë.

 A PaPeR HEART FoR The PeoPLe oF iNSTAGRAM.

ROSES GaLoRE FoR My EDiToR, AMaNDa ENGLaNDeR, Danielle DeSCHeNeS, aND ALL The MAGiCiANS at CLARKSoN PoTTER.

 YELLow TuLiPS iN a VASE FoR MaMa: My Love, My HaPPiNeSS, My FAMiLY.

ABOUT THE AUTHOR

MARI ANDREW IS THE ILLUSTRATOR
BEHIND @BYMARIANDREW. ORIGINALLY
FROM SEATTLE, SHE CURRENTLY
LIVES IN NYC WITH HER
LIPSTICK COLLECTION.

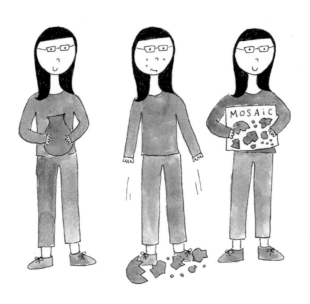